INFINITE DISTANCE
ARCHITECTURAL COMPOSITIONS
BY HELEN LUNDEBERG

INFINITE DISTANCE
ARCHITECTURAL COMPOSITIONS
BY HELEN LUNDEBERG

JUNE 2 - AUGUST 25, 2007

LOUIS STERN FINE ARTS
9002 MELROSE AVENUE WEST HOLLYWOOD CA 90069
WWW.LOUISSTERNFINEARTS.COM

CONTENT

ACKNOWLEDGMENT

This marks the second exhibition in our ongoing re-exploration of the work of the dynamic Southern California painter Helen Lundeberg. Our initial catalogue examined her landscape-based abstractions and now we are moving on to champion her pioneering and visionary architectural compositions. Again, as with our previous exhibition, I find myself marveling at the consistently extraordinary quality and specificity of her work. It seems inevitable, given her remarkable legacy and prodigious accomplishment, that Lundeberg will come to be recognized as one of the foremost artists of her generation. I am delighted to be of service in that cause and also of service in the larger cause of mid-twentieth century Southern California artists in general. It is my intent and great hope, with this exhibition and the series of exhibitions currently in the planning stages, that these groundbreaking artists will finally receive the acclaim, acknowledgment and notoriety their work so richly deserves.

This catalogue simply would not be possible without the support of Wendy Van Haerlem and the Feitelson Arts Foundation. I am tremendously appreciative of the strong working relationship we have built over the years. It has been a great pleasure and a great comfort to have them on my team. For this and their continued collaboration and support, I am ever grateful.

Also, I must extend an especially large word of thanks to our catalogue and exhibition manager Tamara Devrient. She has been efficient, insightful and professional in the face of an unbelievably demanding schedule. Her grace under pressure and her unwavering commitment to this project have been an inspiration to us all.

Last but certainly not least, I want to thank my gallery director Marie Chambers. In one and the same moment, she has written an engaging text, overseen the creation of the catalogue and run the gallery. I'm not sure how she did it but I am certainly glad she did.

Louis Stern

INFINITE DISTANCE
ARCHITECTURAL COMPOSITIONS
BY HELEN LUNDEBERG

Marie Chambers

Helen Lundeberg, August 1974, photo by Fidel Danieli

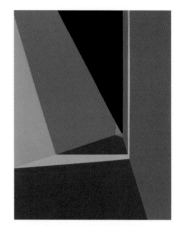

Scene of a Dream, 1961 (pl.19)

"Sometimes there are forms that have been inspired by photographs of architecture and often I don't remember where they have come from or I couldn't find the actual photograph again, but it's just that I have been intrigued by the way the light flows through a tree or the pattern that light made on a column or pillar that had fluting or serrations....I could never...go someplace I like the sound of and make paintings and drawings and so forth. I don't do that. I look, you know? "[1]

What a supremely disciplined and inspired "looker" Helen Lundeberg was.

Throughout this catalogue, in works selected from a forty-year period, in image after image after image, the artist delivers the physically palpable and entirely delicious experience of looking through things. Her paintings move you beyond the curve of the object then out the window to the sea or through the beam of a wall to a ceiling opening where the morning light spills in or around the corner as the sunlight bleeds through dusk to dark. If ever an artist could be honestly accused of 'taking the long view', it is Lundeberg. In truth, 'infinite view' is more appropriate. In these compositions, ruthlessly winnowed to the purest visual necessities, Lundeberg patiently insists we see not just the view, but how she herself understood the view. Even in identifying the work, *Dark View* (pl. 52), *Inner-Outer Space* (pl. 1), *A Quiet Place* (pl. 5), *Silent Interior* (pl. 7 and pl. 10), *Untitled (Moonlight)* (pl. 20), *Scene of a Dream* (pl. 19), the artist announces no destination and, as for traveling, she has already done that for you. All she asks is that you get yourself to the painting and let it carry you from there.

Certainly she possessed considerable gifts in terms of rendering meticulously observed settings. Any casual study of some of her drawings and early studies demonstrates a masterful command of such techniques. Her precocious childhood acumen so charmed her family that, at one moment, they assumed she would make a career as an illustrator.[2] However Lundeberg was not content to paint simply what her eye told her it saw. Though the inspiration may have come from physical fact, the space defined in these 'vistas' defies conventional viewable explanation. Horizons tip at dizzying angles, arches float atop other smaller seemingly backlit arches and the narrowest range of quiet blue grays melt into a strip of heart-stoppingly pungent saffron and, for a moment, your breath simply stops. Lundeberg has commandeered the paint, reined in the color and plied the limitation of the flat plane of the canvas to capture, not something conceptual

or spontaneous, but something completely thought through, thoroughly realized and entirely original. Thus these locations, architectural compositions if you will, are not abstractions, so much as they are inventions; divinely reasonable inventions that pack a considerable emotional punch due in no small part to the artist's unwavering commitment to the rightness of her own inner-directed experience of seeing. Armed with this personal allegiance and utilizing all manner of painterly skills, Lundeberg places her work squarely in the riddle of a classically inclined aesthetic governed by an extremely acute mind's eye. In tracing the discoveries and concerns of that mind's eye, Lundeberg created a dazzling oeuvre that spans Classicism, Surrealism, Post Surrealism or Subjective Classicism and Geometric Abstraction or Hard Edge. With a confluence of this many strong, thoroughly digested influences, it seems positively logical that Lundeberg is not easily categorized. Despite exhibiting in numerous shows meant to define the aforementioned "categories" and unequivocal inclusion in a vibrant circle of influential Southern California based artists, Lundeberg remains brilliantly, genuinely and effortlessly singular.

"There are all kinds of reality. I'm not sure what's meant by it. Oh, well, I've never considered myself a realist, but I sort of dislike that word fantasy; it sounds like, you know, the Disney fairy with her wings fluttering. It bothers me. I've never been interested in realism or naturalism as such, and I mean, you can see that, you can look right through from the beginning to now."[3]

Helen Lundeberg is not for the faint of heart.

Lundeberg was born in Chicago and was 4 years old when her family moved. In an effort to escape the constitution straining cold back east, Lundeberg's family re-located to Pasadena in 1912. Nestled among an extended family already based in Southern California, Lundeberg was earmarked by Stanford University as one of a number of especially brilliant children and received significant familial support for her intellectual strengths. She read voraciously, presumed that writing would most likely become her life's work and surveyed the sun-swept multi-planed landscape of her Pasadena backyard with the acuity of a poet in training. As an adolescent, she made simple sketches, knee-jerk reactions to the lushness of Southern California's natural surroundings. As Ms. Lundeberg once explained, "In those days I had no ideas at all about

Lorser Feitelson and Helen Lundeberg in the back of their Western Avenue studio, 1945

Lorser and Helen at the 3rd Street Studio, 1974, photo by Jale Erzen

becoming an artist. I wasn't aware there was such a thing. But I do think that my turn to art came about from those Sunday afternoons spent reading. I began to read everything but especially novels and travel books. I became such a daydreamer!...I was always a great gazer too. But with so little background in the visual arts it seemed more likely I'd become some kind of writer."[4]

However, her professional/academic future and her family's finances (Lundeberg's father worked for a real estate and stock brokerage firm) were significantly impacted by the stock market crash of 1929 and subsequent onslaught of the Great Depression. After completing the program at Pasadena City College, Lundeberg and her family were in a quandary as to Helen's future. The family consensus was that she should finish school but the times were uncertain. What was a 22 year old with a solid education, genuine intelligence and no clear professional direction to do? A family friend named Helen Leddy, responding to the remembered charm of Ms. Lundeberg's youthful sketches, volunteered tuition payment for Ms. Lundeberg at the Stickney School of Art. It was the summer of 1930 and, unexpectedly, the regular drawing instructor, Lawrence Murphy, was off to Mexico and unavailable to teach. He was replaced, in a moment of supreme good fortune for Lundeberg, by a local dynamo named Lorser Feitelson. This class and their encounter changed the course of Lundeberg's life.

Feitelson, deemed "the standard bearer for the vanguard in Southern California" by the legendary Walter Hopps, employed an analytical approach to drawing, deconstructing the immaculately structured works of his beloved Italians as a springboard for the creation of contemporary works of art. He offered incendiary, deeply felt, rational explanations as to why a composition worked or discovered emotional resonance in the viewer. "When Lorser came and began to explain things, to make diagrams and to give us principles of different kinds of constructions—(whistles) wow, you know, light dawned! It was really very exciting."[5]

Lundeberg's imagination caught fire and she never looked back. All her reading, dreaming, thinking, her very being could be harnessed into this endeavor. She devoured all elements related to the theory and practice of painting and, strongly encouraged by Feitelson, began submitting her work for exhibition in 1931. After steady inclusion in a number of group shows, she was offered her first solo show at Los Angeles' Stanley Rose Gallery in June of 1933. She was 25 years old and she had found her life's vocation in painting and her life long love and partner in Feitelson.

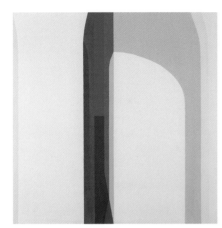

Arches I, 1962 (pl. 23)

"I like working with things, with the actual material. Also I like the fact, in painting, that I have complete control (if I make a mistake, I can correct it, right then and there), that there isn't any guessing as to what's going to come out, as there is when you make a design for a print and somebody else prints it. Yes, I like the act of painting. I like the whole involvement with the thing itself, even though there are times when I wish I could think something onto the canvas. You know, you have a marvelous vision of what you can do; it doesn't always come out that way."[6]

Helen Lundeberg made a remarkable number of highly evocative paintings.

In surveying the pieces chosen for this exhibition, you cannot help but be moved by the persistence of Lundeberg's desire. Once a form seized her attention, she investigated it, reinvented it, let it go, changed its context and then reinvented it again. Though she never aped any of the mid-twentieth century architectural forms springing up around Los Angeles, she built a myriad of timely and timeless structures in the spatial illusions she created on canvas. She spun series based on shapes, *Arches 1,2,3* and so on, adhering masterfully to the mantra of no curves, only straight lines. Then she introduces a single subtly gradated curve and upends the attitude of the space described. Blocks of flat unmodeled geometric areas begin to recede as the rhythmically irregular sequence of straight and angled lines move forward, or vice versa depending on the construct and intent. Your eyes tell you, you are looking through a space where movement occurs. Yet you know very well that there is no movement there in the paint or in the canvas itself. Thus you are left to contemplate the moment before movement, the proverbial quiet before the storm or the sunshine or the rain or perhaps simply the next breath. Fortunately for us, Lundeberg is an authentic sensibility. Her intent is not manipulative; it is revelatory and painting becomes a way of making clear the specifics of being truly present in the room of your life.

Take a look at *Arches I, 1962* (pl. 23). As Lundeberg paints it, who among us has not sat wide-eyed awake amidst the tremulous grays of predawn and glimpsed a sliver of the sharp velvet dark outside our walls? While the complexity of the visual content may have been by design, this kind of hard-edged poetry was not part of the plan.

In 1934, Lundeberg had founded, with Lorser Feitelson, the Post-Surrealist movement. Their manifesto was entitled "New Clacissism" and Helen wrote it. Though certainly influenced by the European Surrealists, Post Surrealists, or Subjective Classicists, intended to use art to explore the relationship between the perceptual and the conceptual without the use of the inexplicable or highly sexualized imagery of their European predecessors. During this period, Lundeberg painted classically oriented arrangements featuring imagery rooted in a knowable, recognizable world. Of her initial unexpected foray into decidedly Hard Edge painting in 1950 Lundeberg commented," I had begun to use very flat abstract planes as a setting for things like shells and clouds and their shadows or bowls of fruit. Then I found myself sitting down one day and doing a painting where I couldn't put anything in it. It was complete in itself. I called it *A Quiet Place* (pl. 5) and I didn't know quite what to make of it. It rather surprised me and it seemed very inconsistent in terms of what I was doing, so I put it aside."[7] But she did not put this surprise aside for long. Nor did she ever abandon her exquisitely articulated notion of seeing (and thus painting) as a means of contacting an understanding greater than the sum of all parts.

Again, Lundeberg exhibited unflinching faith in her identity and concerns as an artist. She began experimenting with the plain white of the canvas as a color, thus rewriting the use of positive and negative space in her constructs. In order to sustain the innate color of the canvas (pencil and charcoal left smudges) she began to use tape to sculpt her precisely gradated planes. New impulses were pursued with a ruthless integrity and honored when they served her creative purposes. Ultimately, in 1965, she even abandoned oil paint because she had fallen in love with the freshness and clean dry texture achievable only via acrylic. Though Lundeberg may have retained her subjective classicist's heart, this was a decidedly "hard edge" decision.

"Now, there was a time in the early sixties, around 1960-61, when I was working in a very dark palette. And I became fascinated with this thing. It doesn't come from nature, and it doesn't come from any emotional mood, either, because I was in a perfectly happy state of mind. People began to say, "What's the matter with her? Is she in a depression or something?" Because I was working in black, umber, gray and so forth. And to me it was perfectly beautiful. You sit and you look at your own canvas, you know, and you see all the subtle relationships. But to somebody else, it looks just plain gloomy, sometimes. And I went through a state of that. Then, having mined that vein for a while, I began working with the white of the canvas, and they perked up no end. (laughter)" [8]

Beauty, quite naturally, defies categorization and poetry is hard work.

If Lundeberg's compositions are intellectually rigorous, her colors are marvels of understated emotion. Her greens seem to have light shot through them. Her browns, from chocolate to mud to ruddy taupe, collide into one another with the ease of ancient beloveds. And there is a shade of buttery bronze, employed in slight variations by the artist in numerous works, that communicates the heat of the sun as deftly as the sun itself. By working with an unusually narrow range of colors, Lundeberg builds a carefully refined relationship betwixt the space depicted and the viewer.

Look at *Enigma of Reality, 1955* (pl. 8). It was executed in the middle of the decade in which she moved decisively towards a Hard Edge vocabulary in her painting. Illogically, the flat expanses of its highly nuanced color (a box of grainy taupe, an elongated triangular plane of moss brown, a cube of blue shrouded in uneven patches of gray-green) map the location with great specificity. Though the location is not quite "real," it features objects (the wall, the table, the fruit and the flower vase) that are entirely real, understandable. The scene feels authentic, looks complete. But the mind struggles to make the setting make sense. What kind of greenish wall could reasonably be butted up against the muted tan of the adjacent wall? What is the scale of the canvas painted on the canvas? And how can the sea and the perspective-jolting wall be almost the same color? Reason never surrenders without a fight. However, the rhythm of Lundeberg's subtly cascading, and no doubt hard won, palette seduces even the obstinate. No matter how many times you run your calculating eyes across the painting, the color pulls you through the subject material, past the logic and all the way out to the evanescent aqua blue at its center. This aqua blue somehow carries the heart of the painting. It trumps all the earth-toned shapes and objects in the foreground and transforms the meaning of the composition. Is this the slightly camouflaged blue of sky or is it some wordless eternity beyond the sky? Or is it just a dream? Whatever it may be, in this and in later more bare-bones constructs as well, Lundeberg has earned her poetry. In the same moment, she has also earned, without even a glimmer of affect, our undivided attention.

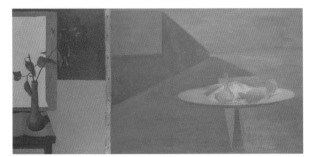

Enigma of Reality, 1955 (pl. 8)

"You'll have to ask me questions, because either I'll go on forever or I won't say a word." [9]

Perhaps if we all painted, we would not waste so much time talking.

Could the engine of these paintings be summarized as the act of seeing or looking in order to see? The great seventeenth century classicist painter Nicolas Poussin has explained it thus: "There are two ways of looking at objects: one is simply to look at them, the other is to look at them attentively. Simply to look at them is no more that to receive naturally upon the eye the shape and appearance of the object in question. But to look at an object attentively means... to find out carefully the way of knowing the object well. Thus it can be said that to look at a thing is a natural function whereas what I should call seeing a rational process." [10]

As all of the works included in this exhibition illustrate, Helen Lundeberg, quite rationally, looked in order to see. And, oh, what visions and what vision these paintings reveal. One wonders if contemporary light and space artists such as James Turrell and Robert Irwin have ever run their eyes across any of Lundeberg's provocative spatial constructs. Certainly they have each run their mind's eye across issues kindred to those present in Lundeberg's architectural compositions. However profound Lundeberg's influence on contemporary artists may be, the conversation as ever, returns to the experience of seeing and the significant pleasure of knowing what you see. On these two counts, and in any generation, Ms. Lundeberg is simply inspirational.

Enough talk. Turn the page. Have a look. See for yourself.

Marie Chambers

1. Helen Lundeberg, interviewed by Jan Butterfield, 1981-82.
2. Helen Lundeberg, *Helen Lundeberg*, Oral History Program, University of California,
 Los Angeles (1982), interviewed by Fidel Danieli (©1982 The Regents of The University
 of California, All Rights Reserved. Used with Permission). Transcript p. 12.
3. Helen Lundeberg, quoted in transcript p. 72.
4. Helen Lundeberg, interviewed by Jan Butterfield, 1981-82.
5. Helen Lundeberg, quoted in transcript p. 13.
6. Helen Lundeberg, quoted in transcript p. 54.
7. Helen Lundeberg, quoted in Joseph E. Young, *"Helen Lundeberg:
 An American Independant,"* Art International, September 1971, p.46
8. Helen Lundeberg, quoted in transcript p. 58, 59.
9. Helen Lundeberg, quoted in transcript p. 13.
10. Nicolas Poussin, quoted by Jules Langsner in *Four Abstract Classicists*,
 essay for exhibition catalogue produced by San Francisco Museum of Art
 and the Los Angeles County Museum, 1959, p.10.

*Marie Chambers is director
of Louis Stern Fine Arts.*

PLATES

INNER/OUTER SPACE

c. 1943

oil on board
6 x 39 inches
15.2 x 99 centimeters
L4301B

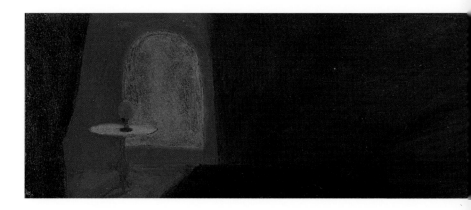

1

THE PIER

1943

oil on board
5 1/4 x 9 3/4 inches
13.3 x 25 centimeters
L4302B

2

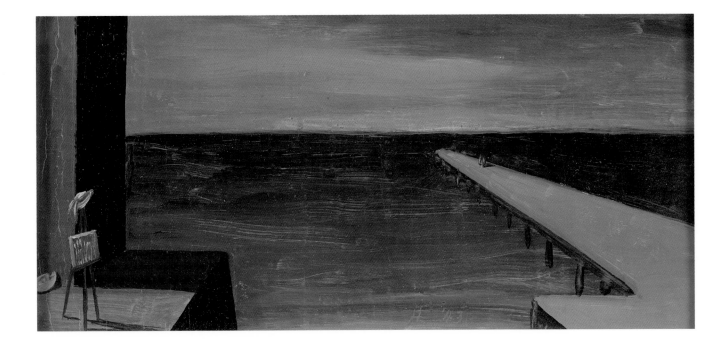

ABANDONED EASEL

1946

oil on board
5 1/4 x 10 1/4 inches
13.3 x 26 centimeters
L4601B

3

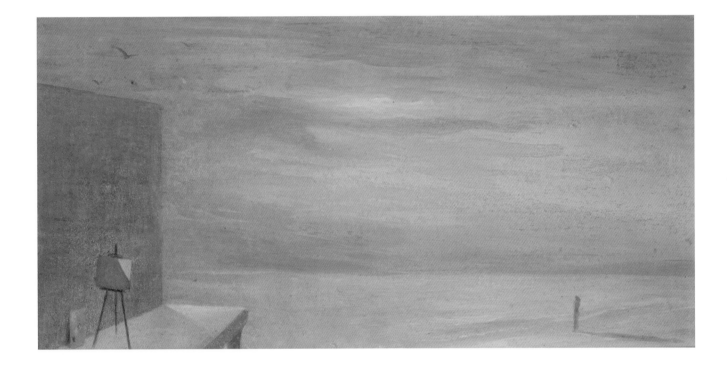

WINTER SUN

1949

oil on canvas
24 x 20 inches
61 x 51 centimeters
L4902C

4

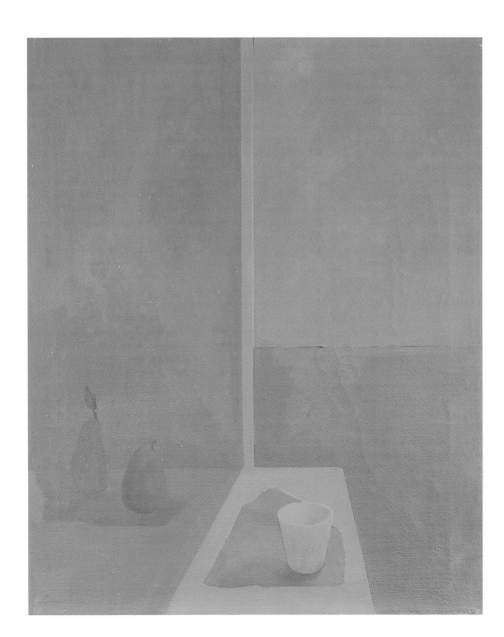

A QUIET PLACE

1950

oil on canvas
16 x 20 inches
40.6 x 50.8 centimeters
L5002C

5

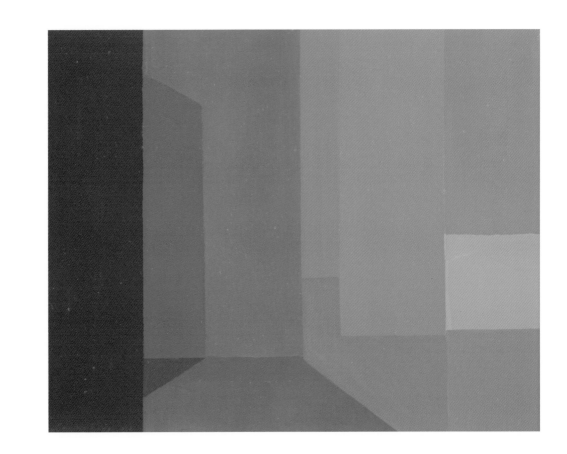

NIGHT

1951

oil on board
4 3/4 x 10 1/4 inches
12.1 x 26 centimeters
L5101B

6

SILENT INTERIOR

1952

oil on canvas
30 x 36 inches
76.2 x 91.4 centimeters
L5201C

7

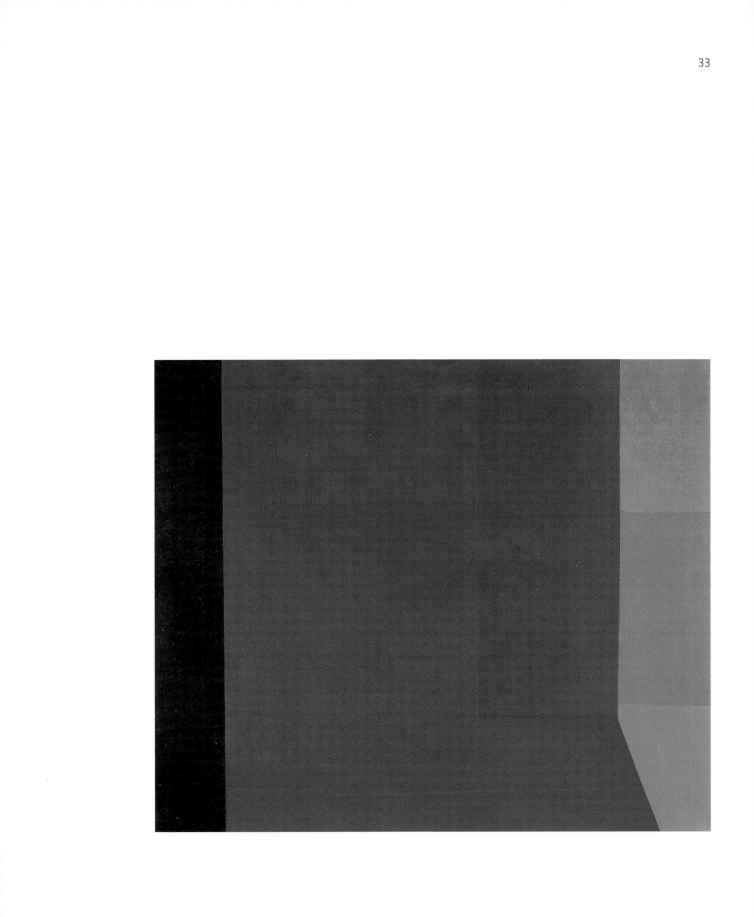

ENIGMA OF REALITY

1955

oil on canvas
20 x 40 inches
50.8 x 101.6 centimeters
L5503C

8

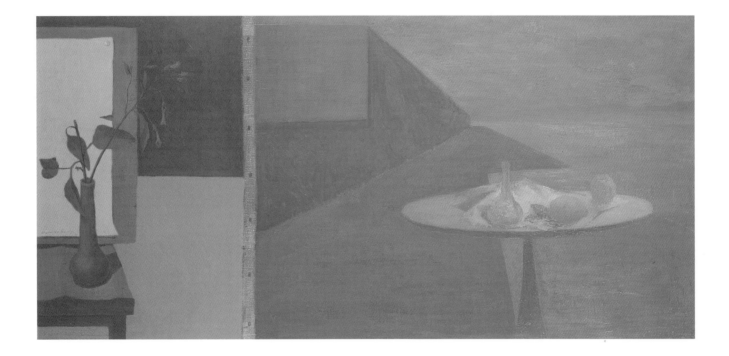

THE ROAD

1958

oil on canvas
20 x 36 inches
50.8 x 91.4 centimeters
L5801C

9

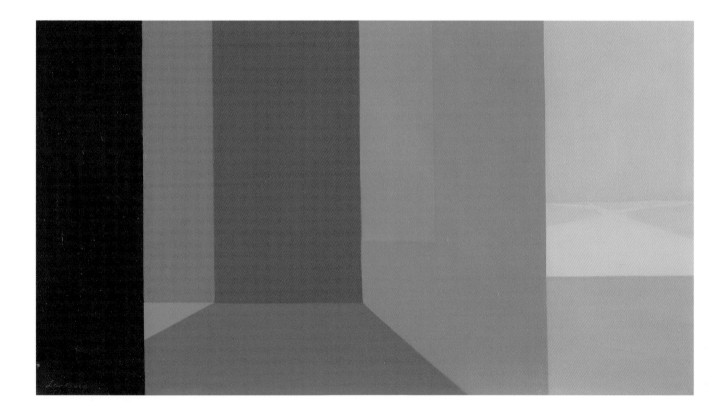

SILENT INTERIOR

1959

oil on canvas
50 x 60 inches
127 x 152.4 centimeters
L5901C

10

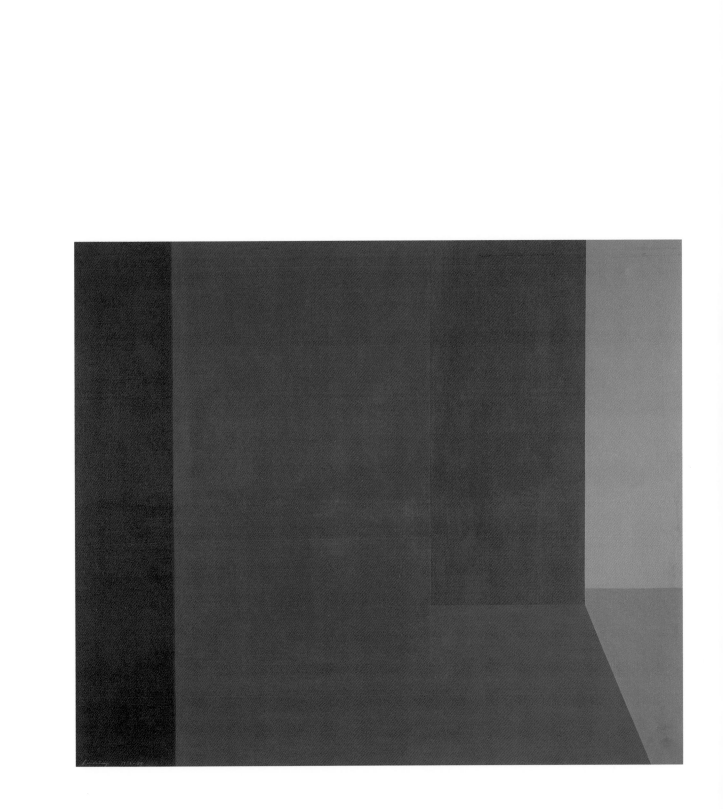

DARK CORRIDOR

1959

oil on canvas
20 x 21 inches
50.8 x 53.3 centimeters
L5903C

11

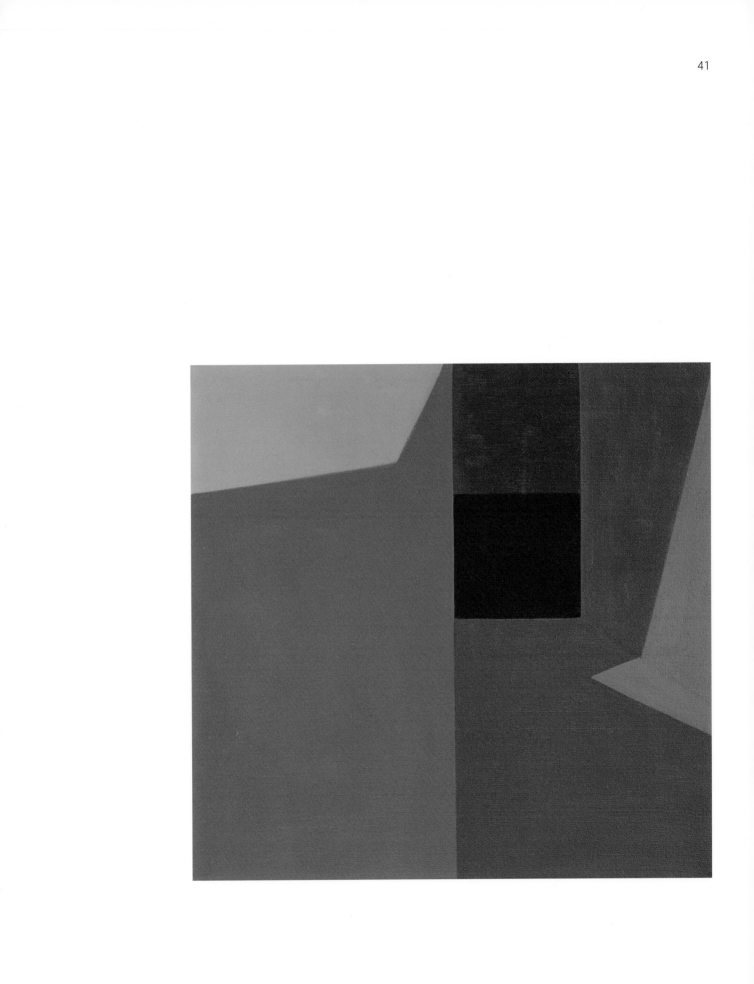

LIGHT PATH TO THE SEA

1959

oil on canvas
16 x 20 inches
40.6 x 50.8 centimeters
L5906C

12

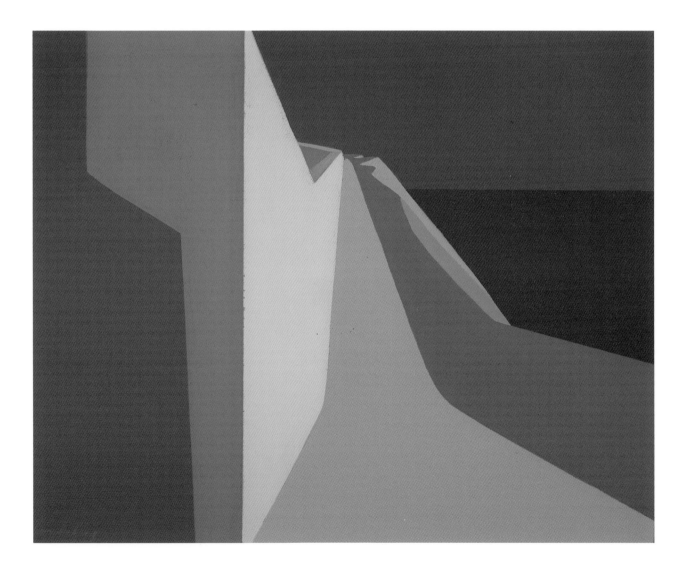

SUNNY CORRIDOR

1959

oil on canvas
20 x 24 inches
50.8 x 61 centimeters
L5907C

13

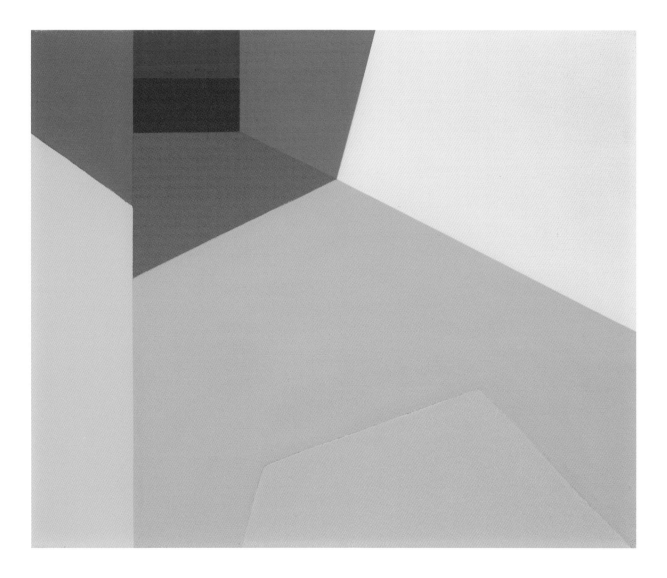

UNTITLED

1960

acrylic on canvas
16 x 20 inches
40.6 x 51 centimeters
L6005A

14

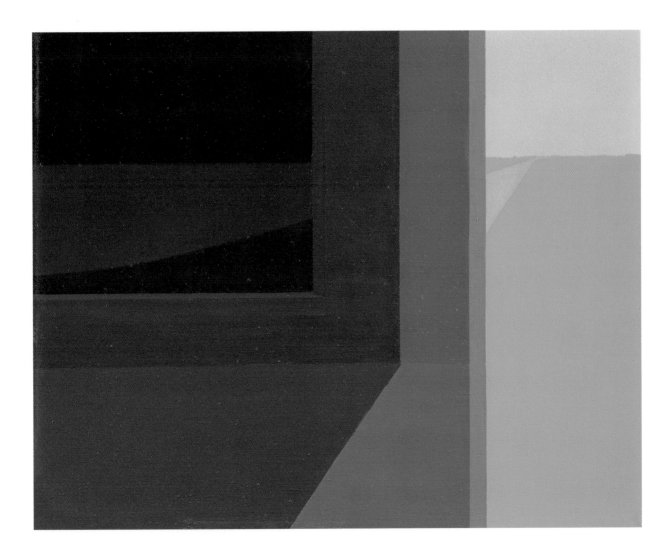

UNTITLED

1960

oil on canvas
24 x 36 inches
61 x 91.4 centimeters
L6006C

15

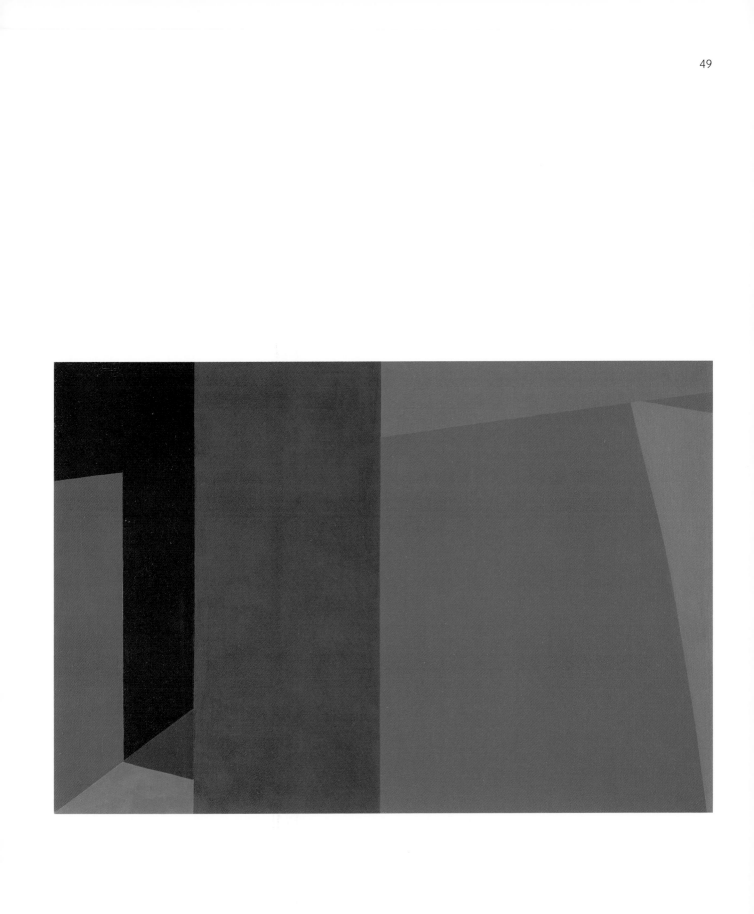

INTERIOR WITH TABLE

1960

oil on canvas
36 x 30 inches
91.4 x 76.2 centimeters
L6007C

16

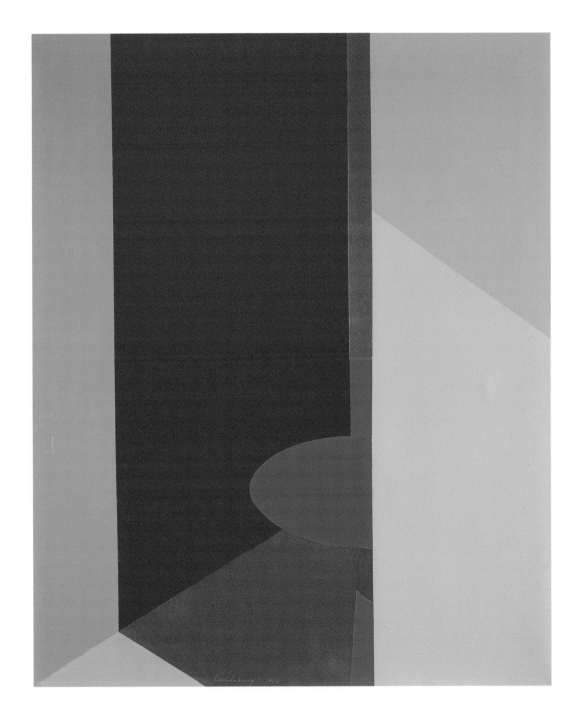

STREETLIGHT IN SHADOWS

1960

oil on board
12 x 16 inches
30.5 x 40.6 centimeters
L6012B

17

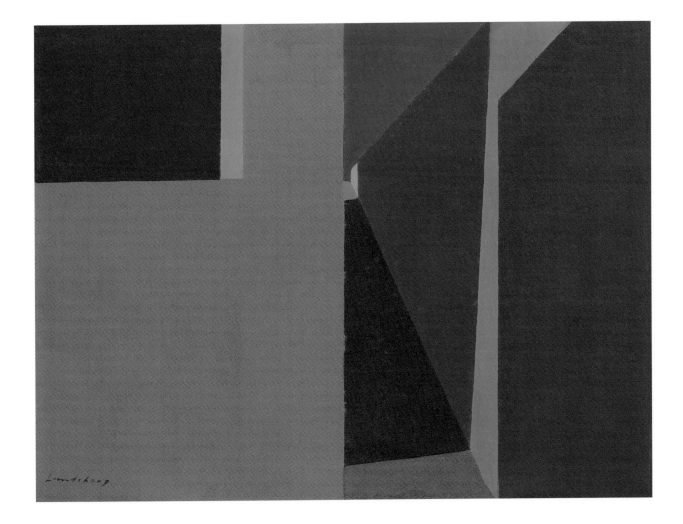

INTERIOR WITH MIRROR

1961

oil on canvas
50 x 40 inches
127 x 101.6 centimeters
L6103C

18

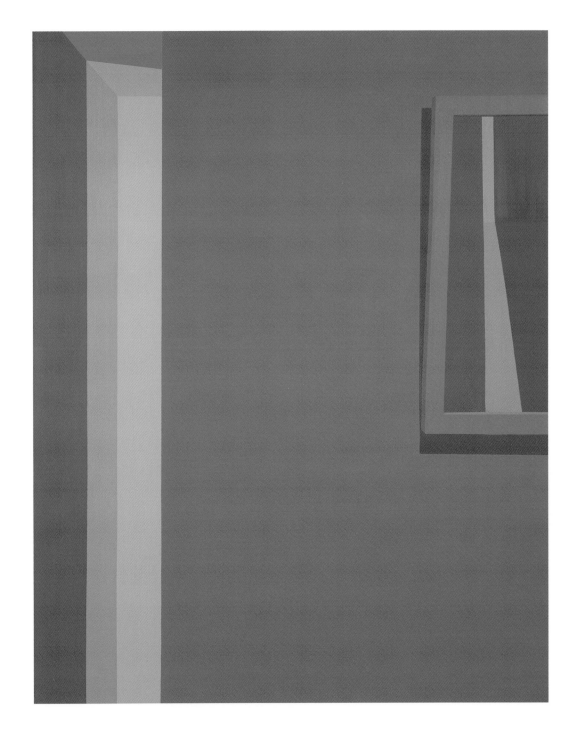

SCENE OF A DREAM

1961

oil on canvas
50 x 40 inches
127 x 101.6 centimeters
L6106C

19

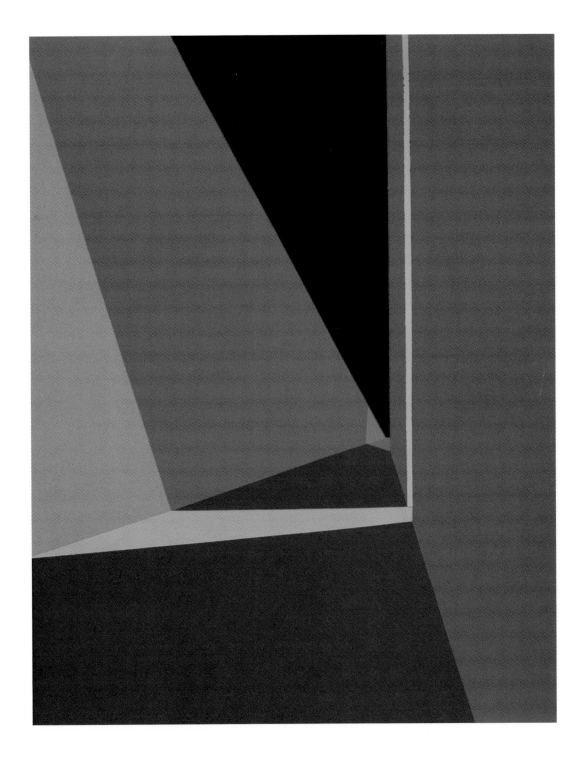

UNTITLED (MOONLIGHT)

1961

oil on canvas
24 x 20 inches
61 x 50.8 centimeters
L6108C

20

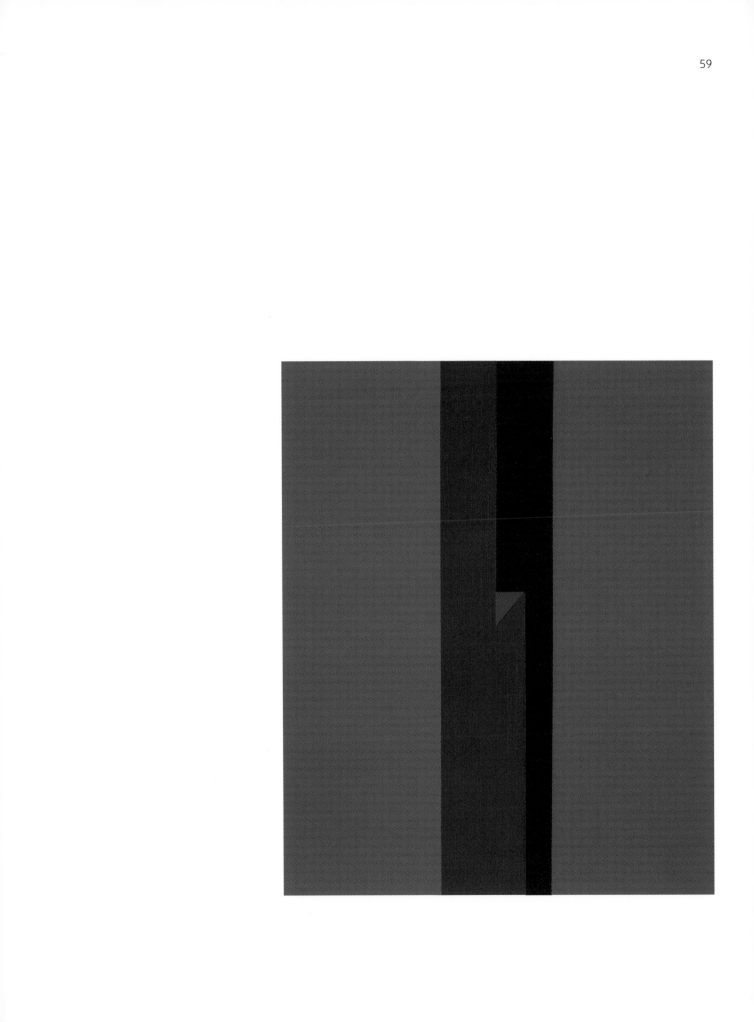

ARCHES

1962

acrylic on canvas
8 x 10 inches
20.3 x 25.4 centimeters
L6214A

21

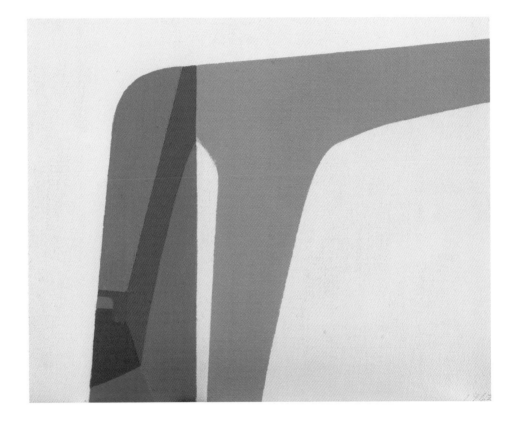

UNTITLED (ARCHES II)

1962

oil on canvas
30 x 50 inches
76.2 x 127 centimeters
L6203C

22

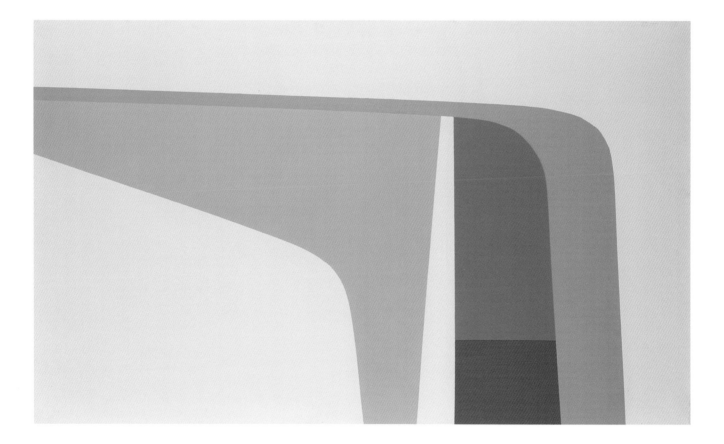

ARCHES I

1962

oil on canvas
36 x 36 inches
91.4 x 91.4 centimeters
L6204C

23

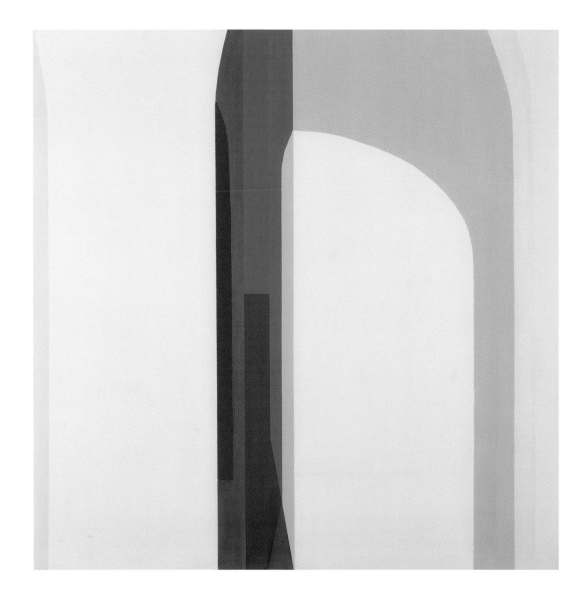

UNTITLED

1962

oil on canvas
50 x 50 inches
127 x 127 centimeters
L6206C

24

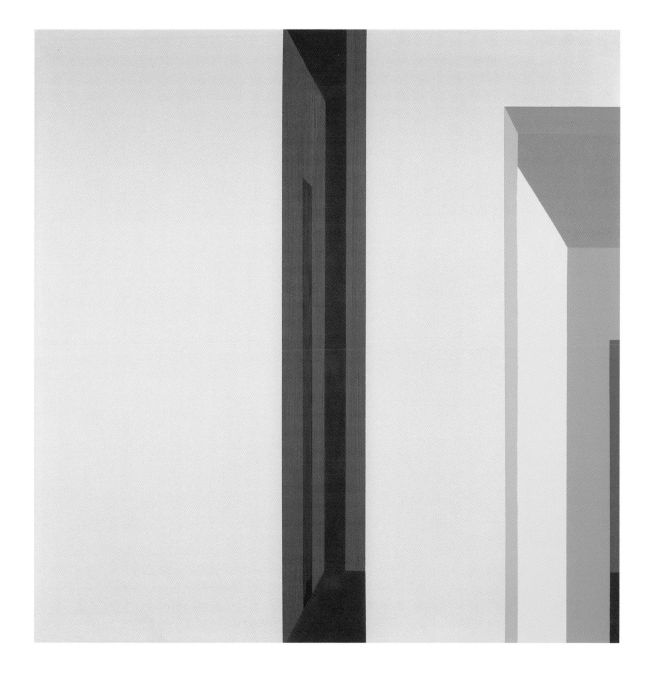

ARCHES 5

1962

oil on canvas
48 x 91 inches
122 x 231 centimeters
L6205C

25

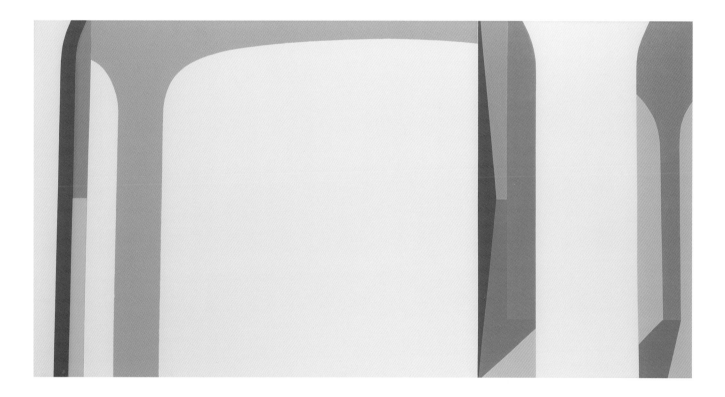

INTERIOR WITH LIGHT PATHS

1962

oil on canvas
24 x 30 inches
61 x 76.2 centimeters
L6208C

26

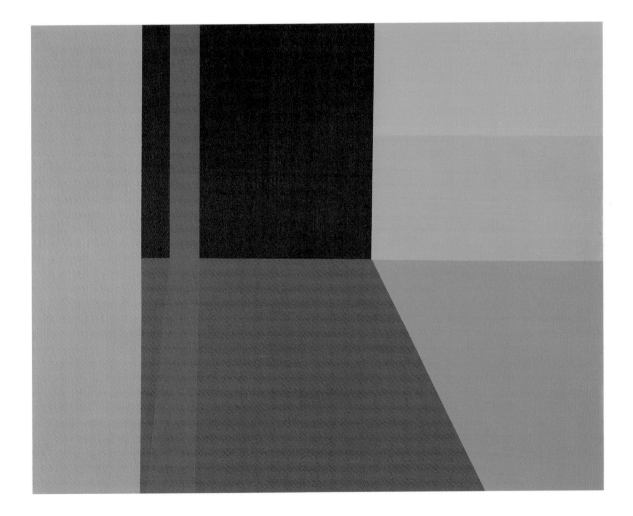

SHADOW OF THE BRIDGE I

1962

oil on canvas
24 x 30 inches
61 x 76.2 centimeters
L6211C

27

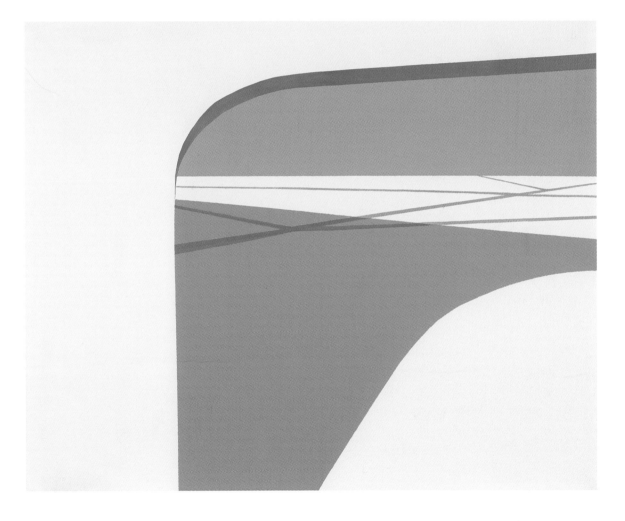

UNTITLED
(INTERIOR WITH DOORWAY)

1962

oil on canvas
30 x 24 inches
76.2 x 61 centimeters
L6201C

28

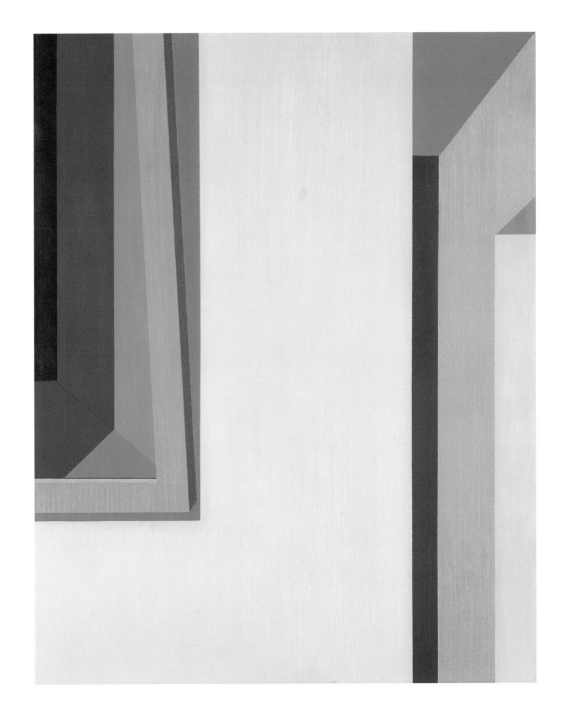

UNTITLED

1963

oil on canvas
40 x 60 inches
101.6 x 152.4 centimeters
L6302C

29

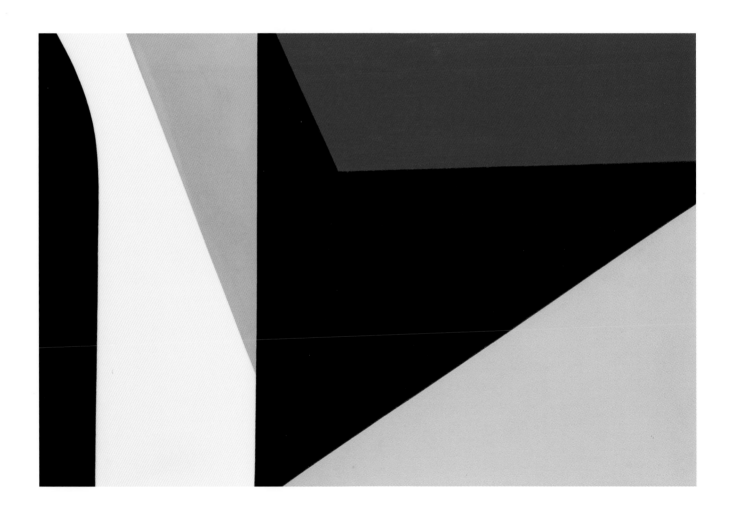

UNTITLED

July 1964

acrylic on canvas
36 x 36 inches
91.4 x 91.4 centimeters
L6401A

30

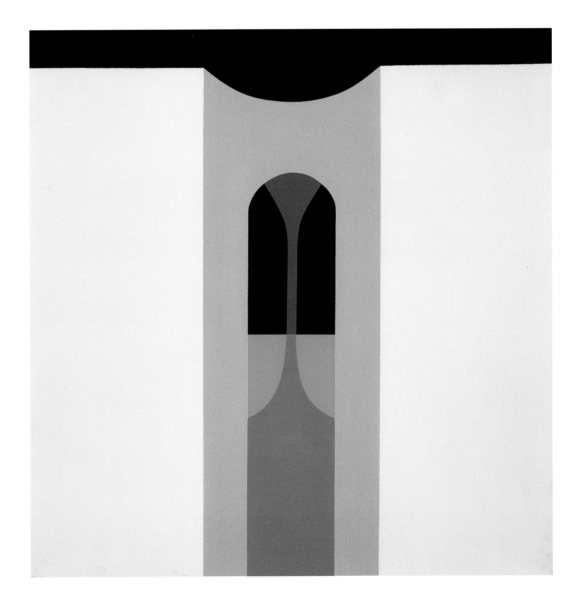

UNTITLED
(LOOKING THROUGH SERIES)

1964

acrylic on canvas
60 x 60 inches
152.4 x 152.4 centimeters
L6402A

31

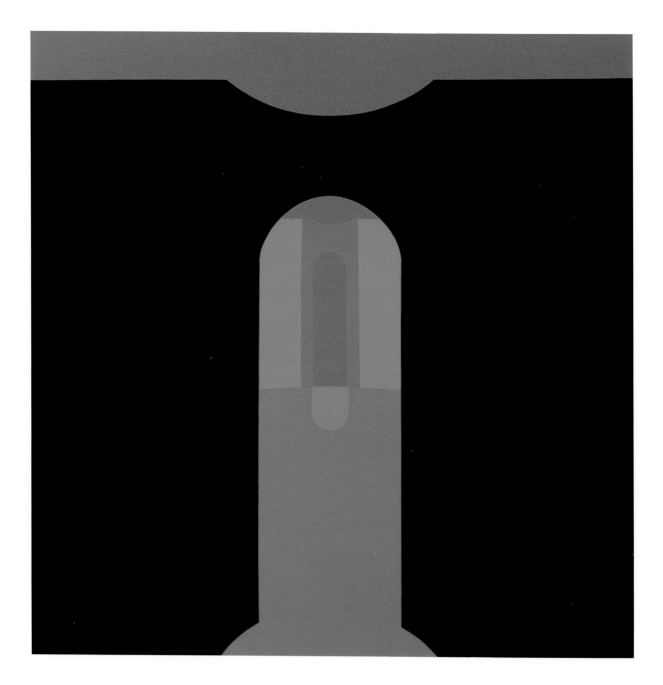

LOOKING THROUGH

1964

oil and enamel on canvas
60 x 60 inches
152.4 x 152.4 centimeters
L6403C

32

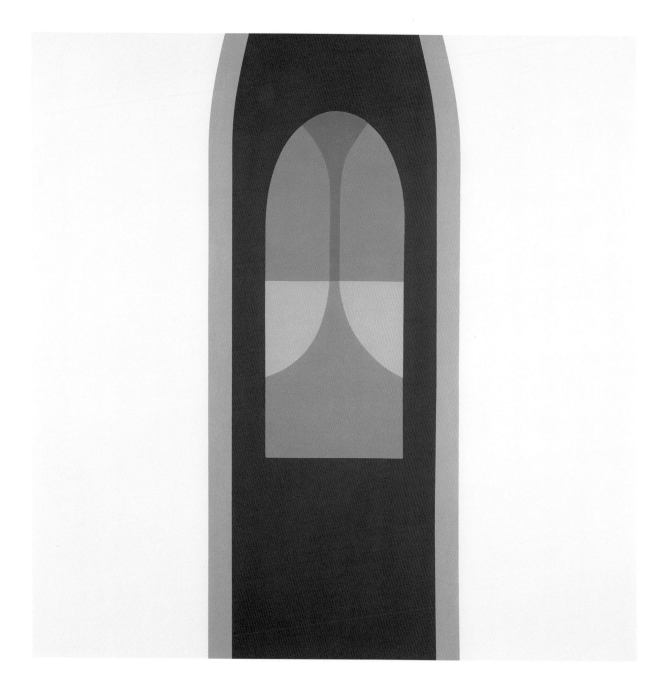

KURIGALZU'S ARCH

1964

acrylic on canvas
60 x 60 inches
152.4 x 152.4 centimeters
L6404A

33

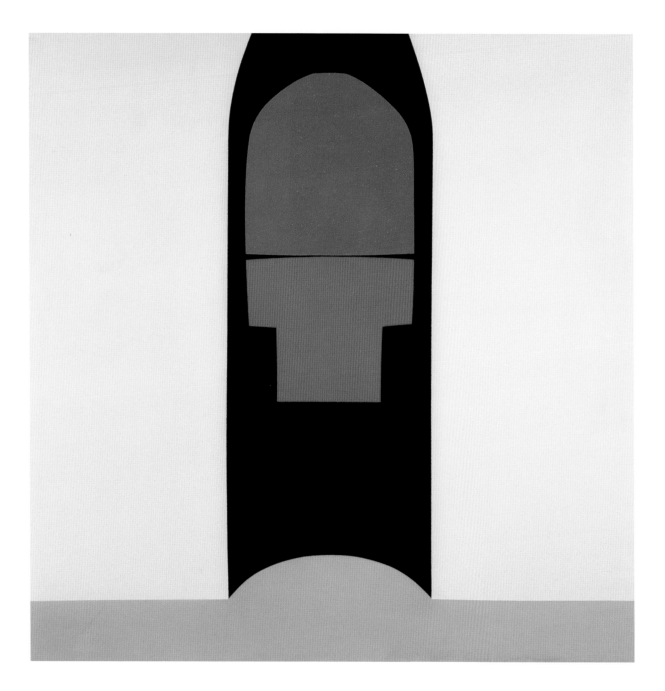

MOONLIGHT

1964

acrylic on canvas
60 x 60 inches
152.4 x 152.4 centimeters
L6405A

34

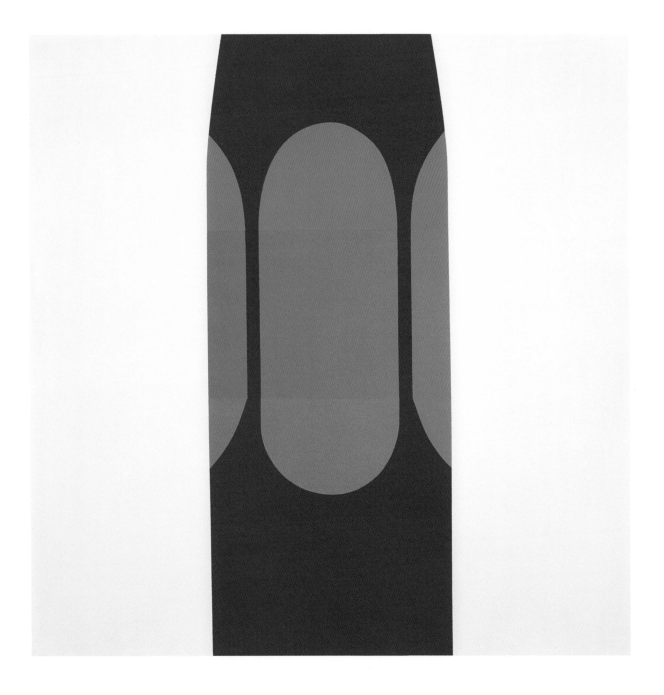

DESERT LIGHT

1964

oil on canvas
36 x 36 inches
91.4 x 91.4 centimeters
L6407C

35

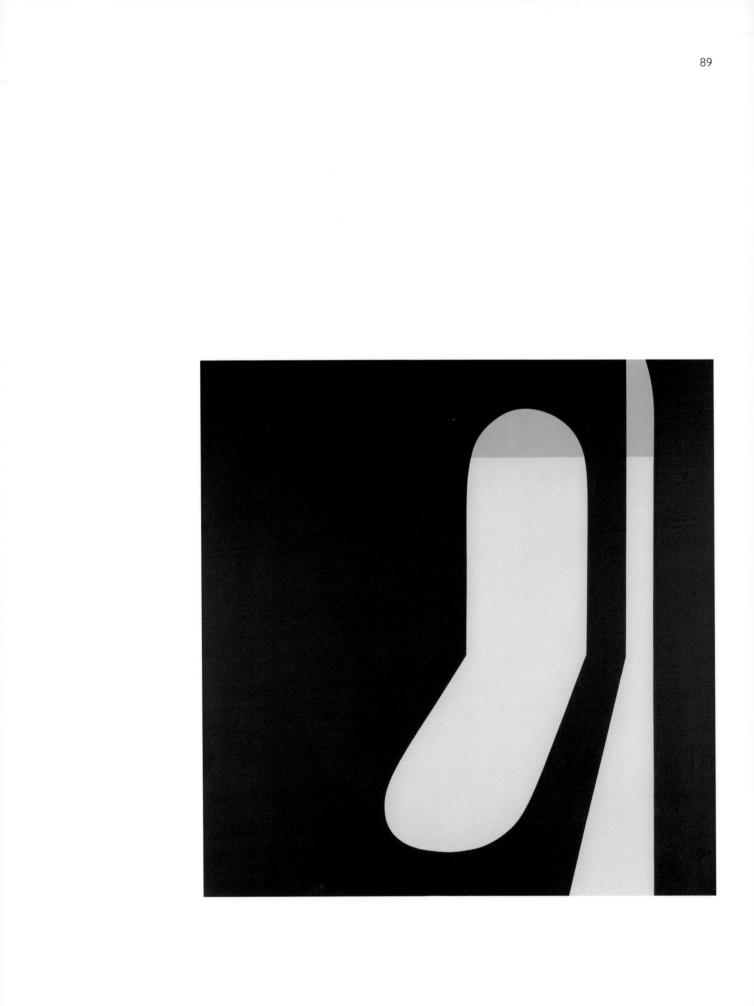

EVENING VIEW

1964

acrylic on canvas
60 x 40 inches
152.4 x 101.6 centimeters
L6408A

36

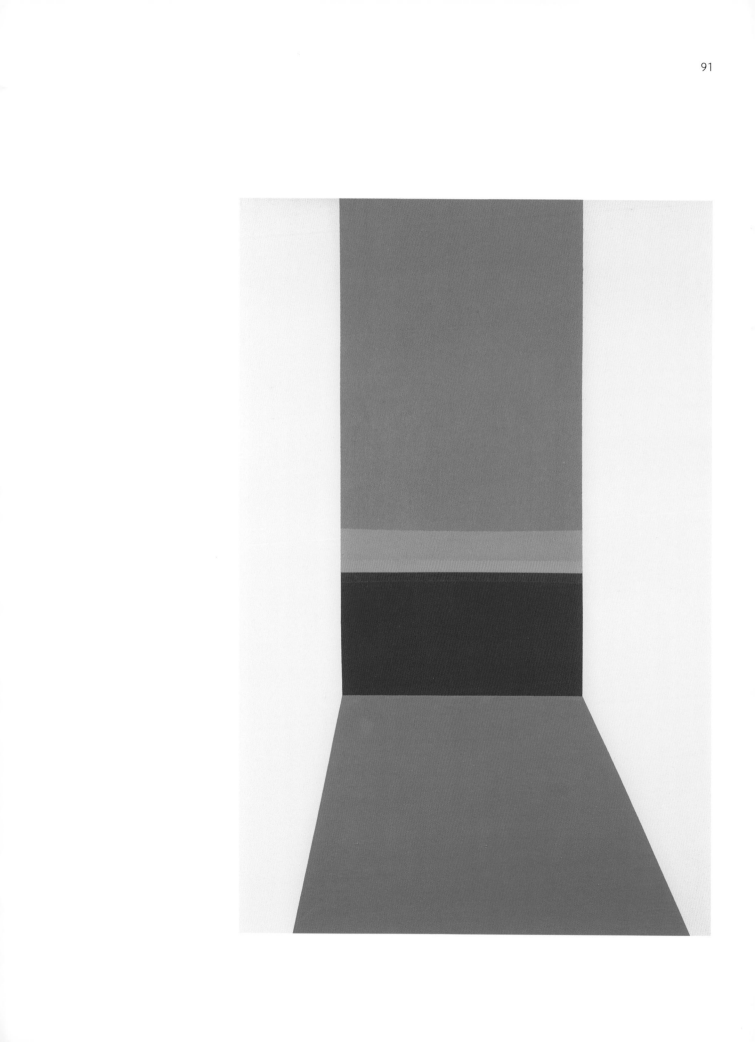

VIEW FROM AN ARCADE

1964

acrylic on canvas
60 x 40 inches
152.4 x 101.6 centimeters
L6409A

37

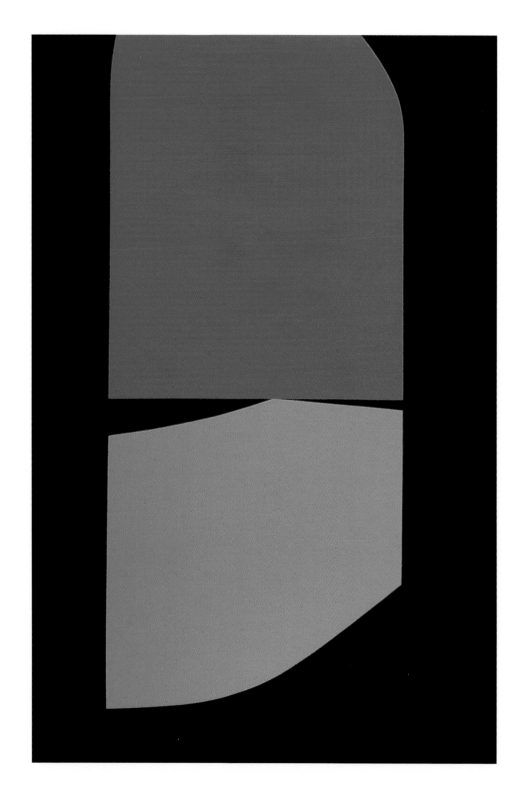

ARCANUM I

1967

acrylic on canvas
60 x 40 inches
152.4 x 101.6 centimeters
L6702A

38

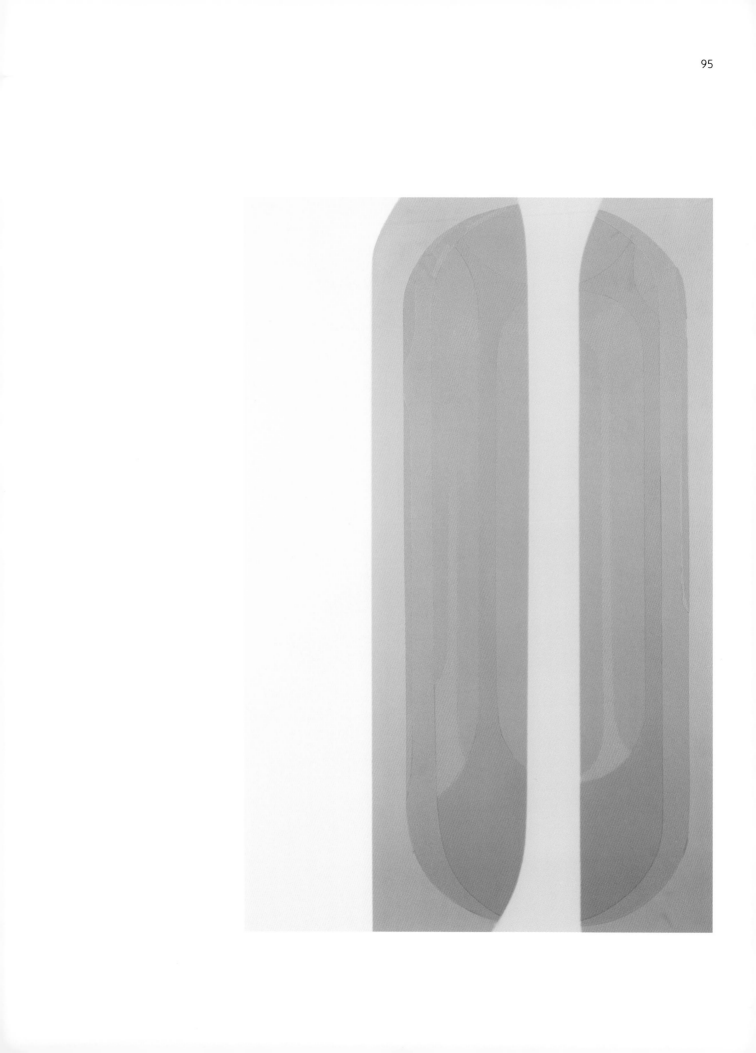

UNTITLED

1967

acrylic on canvas
60 x 60 inches
152.4 x 152.4 centimeters
L6703A

39

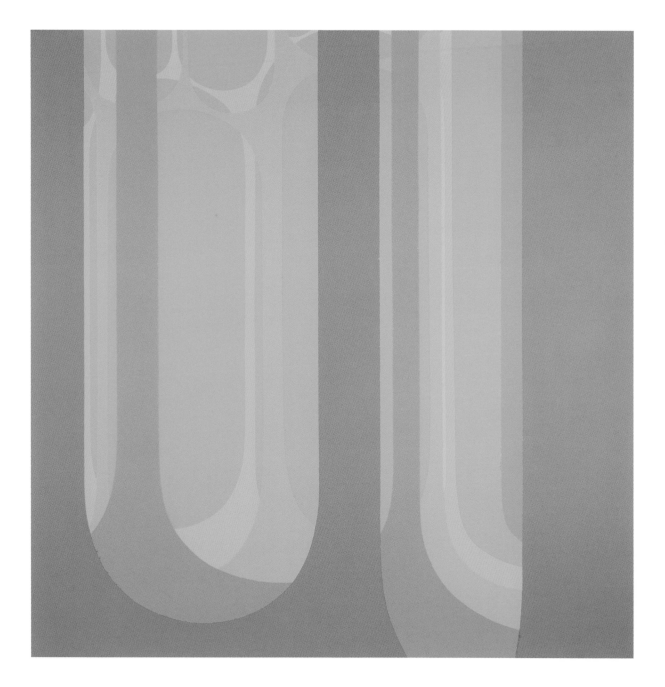

UNTITLED

1969

acrylic on canvas
36 x 36 inches
91.4 x 91.4 centimeters
L6905A

40

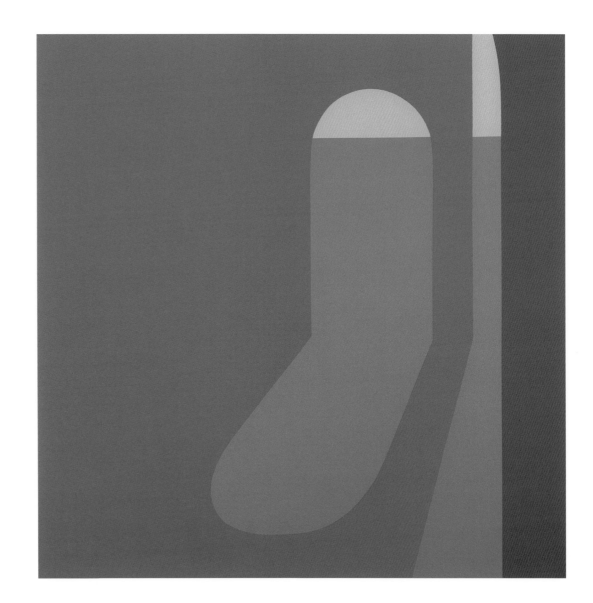

THE MIRROR AND PINK SHELL

1969

acrylic on canvas
40 x 60 inches
101.6 x 152.4 centimeters
L6909A

41

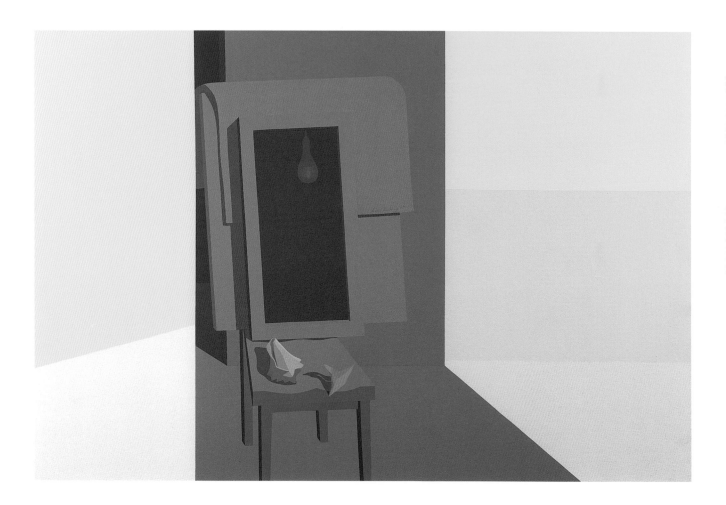

UNTITLED

1970

acrylic on canvas
54 x 30 inches
137 x 76.2 centimeters
L7006A

42

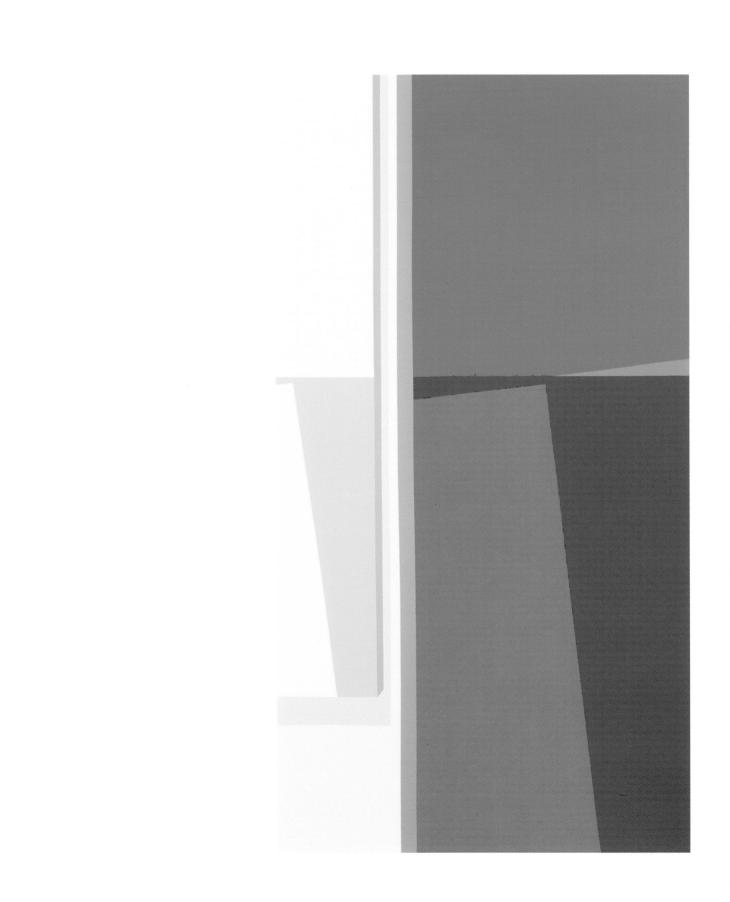

ARCANUM # 6

1970

acrylic on canvas
60 x 60 inches
152.4 x 152.4 centimeters
L7009A

43

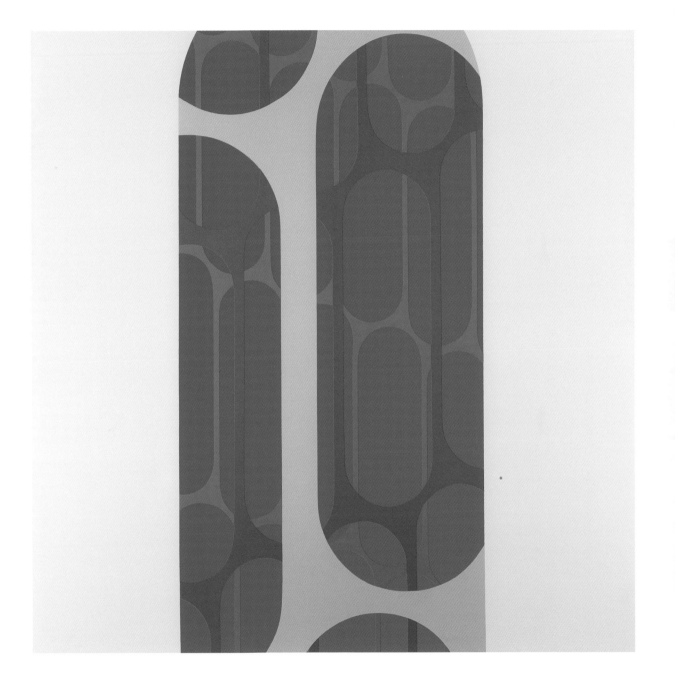

ARCANUM # 7

1970

acrylic on canvas
60 x 60 inches
152.4 x 152.4 centimeters
L7010A

44

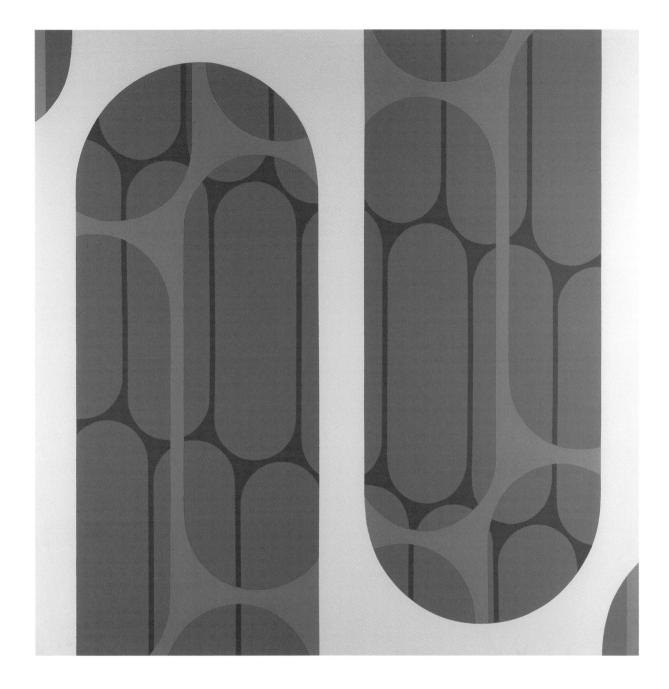

ARCANUM

1970

acrylic on canvas
20 x 20 inches
50.8 x 50.8 centimeters
L7013A

45

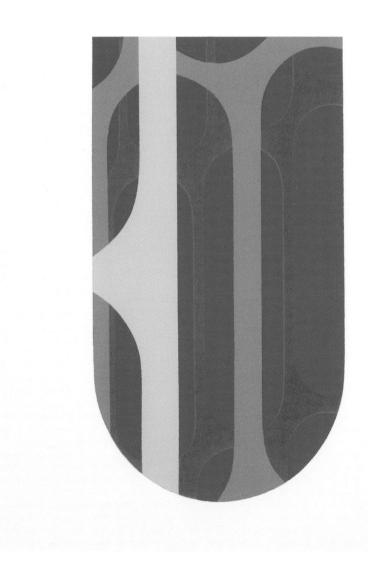

UNTITLED

March 1973

acrylic on canvas
60 x 40 inches
152.4 x 101.6 centimeters
L7303A

46

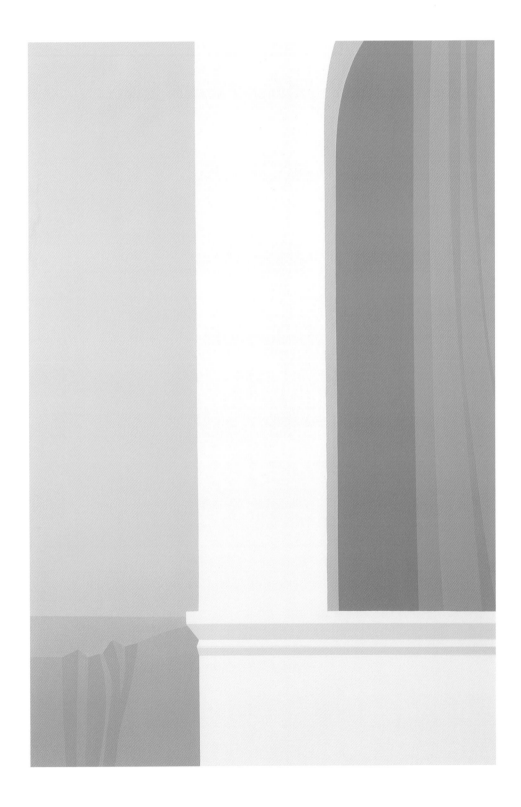

UNTITLED

May 1973

acrylic on canvas
40 x 60 inches
101.6 x 152.4 centimeters
L7301A

47

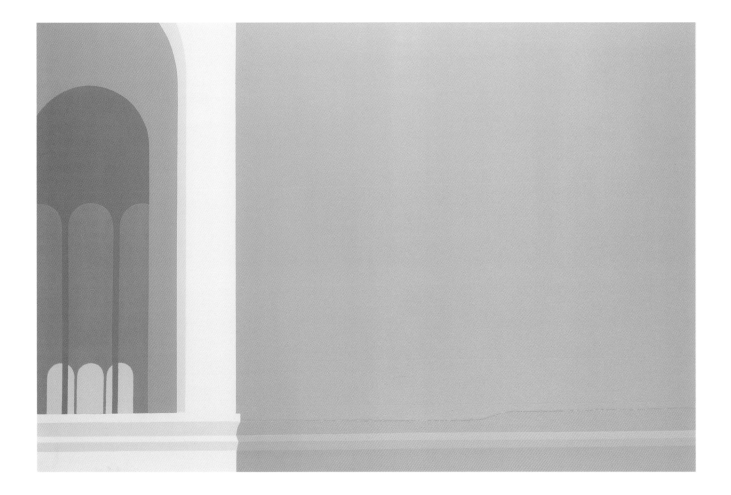

UNTITLED
(CLASSIC LANDSCAPE)

March 1973

acrylic on canvas
60 x 40 inches
152.4 x 101.6 centimeters
L7302A

48

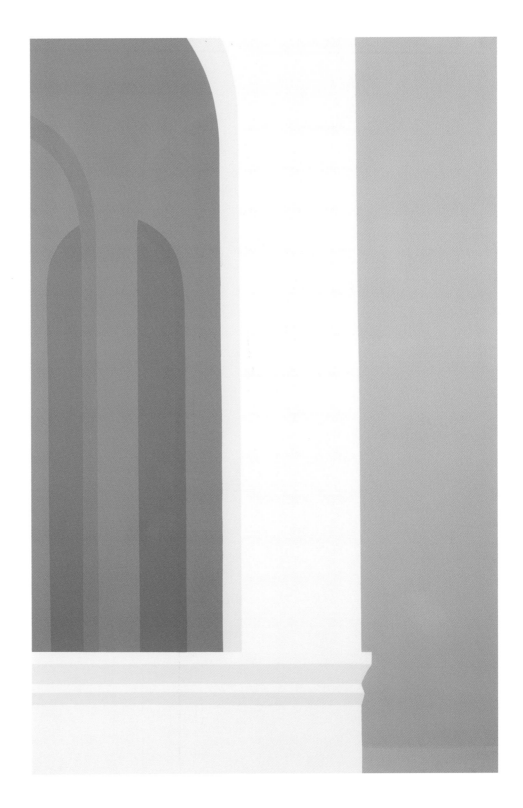

DOUBLE VIEW

1973

acrylic on canvas
12 x 16 inches
30.5 x 40.6 centimeters
L7304A

49

UNTITLED

1974

acrylic on canvas
36 x 36 inches
91.4 x 91.4 centimeters
L7401A

50

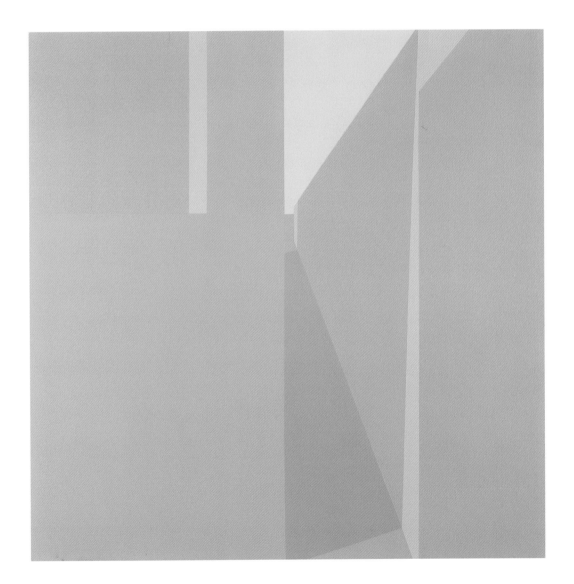

BLUE VIEW

1974

acrylic on canvas
60 x 60 inches
152.4 x 152.4 centimeters
L7402A

51

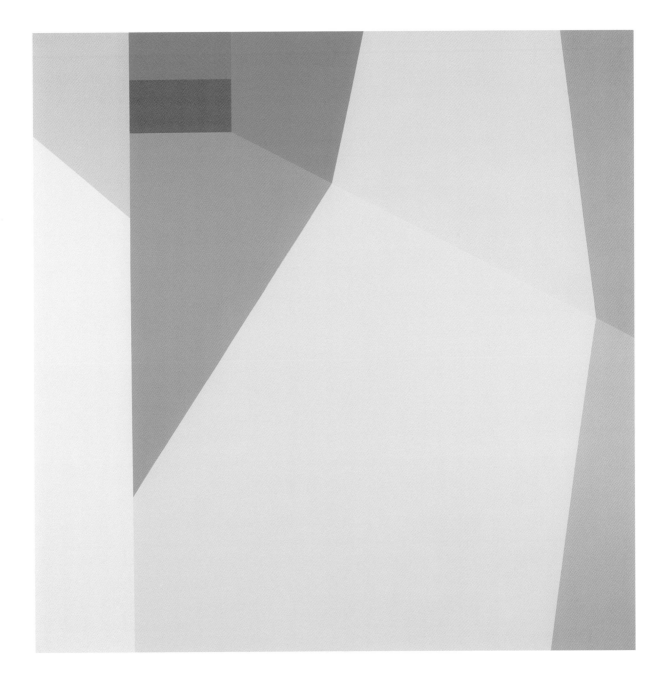

DARK VIEW

1974

acrylic on canvas
60 x 60 inches
152.4 x 152.4 centimeters
L7403A

52

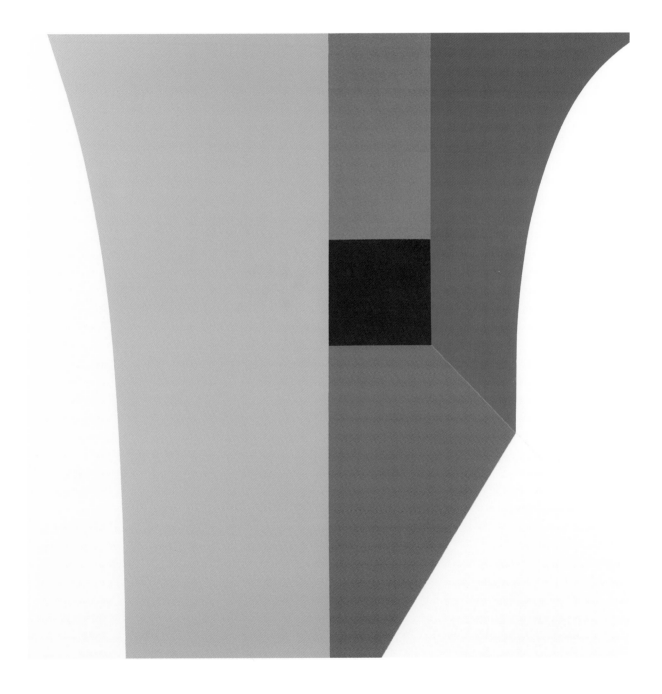

UNTITLED (EVENING LIGHTS
AND SHADOWS)

1975

acrylic on canvas
14 x 18 inches
35.5 x 45.7 centimeters
L7502A

53

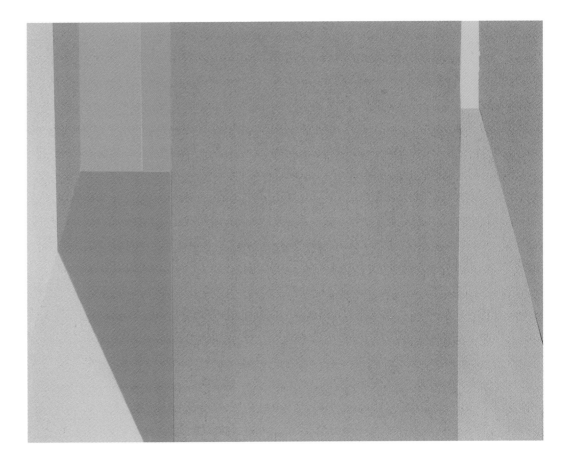

RED PEARS

1987

acrylic on canvas
35 x 50 inches
88.9 x 127 centimeters
L8702A

54

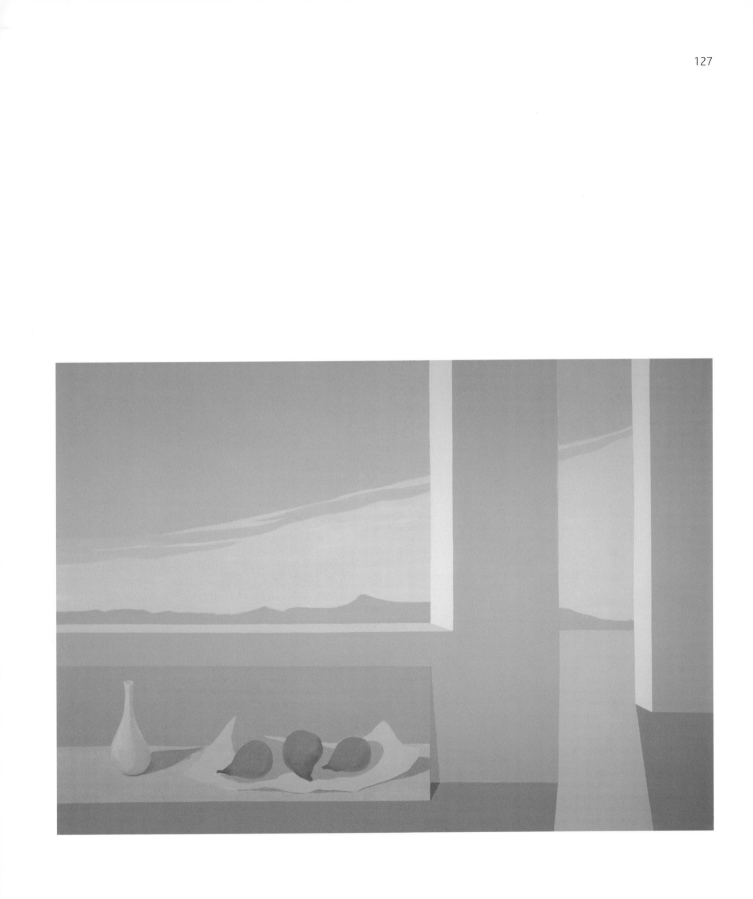

CHRONOLOGY

Helen Lundeberg, circa 1912

1908
Born in Chicago, June 24, to second–generation Swedish parents.

1911
Birth of younger sister Inez Selma.

1912
Family moves to Pasadena, California, where her father works for a real estate and stock brokerage company.

1914
Attends Longfellow Grammar School after having learned to read at home.

1921
Graduates from grammar school; enters Pasadena High School.

Participates in a program, "Study of Gifted Children" conducted by Stanford University to study the characteristics and development of children who ranked in the top 1% in California schools. Follow-up continues through 1945.

1925
June. Finishes high school. Remains at home that summer until the Fall of 1927 to help her mother, who is ill. Reads extensively during this time, including novels, poetry, and travel books. Goes to Sunday school and church, primarily for the music and the peaceful ambience.

1927
Begins Pasadena City College. Spends an extra semester catching up on Algebra and Geometry, not taken in high school. Enjoys both.

1930
Graduates from junior college. Spring. Family friend sponsors classes for three months at Stickney Memorial School of Art in Pasadena. Studies with Lawrence Murphy who teaches Bridgman-style figure construction and composition class.

Summer. Lorser Feitelson takes over classes from Murphy. Bridgman style no longer taught. Under Feitelson, both classes include discussion and graphic analyses of the structural principles of early and late Renaissance masters, as well as Moderns. Learns to distinguish art from illustration.

1931
June. Encouraged by Lorser Feitelson, submits and exhibits first figure painting, **Apple Harvest**, in the "Sixth Annual Exhibition of Southern California Art" at the Fine Arts Gallery of San Diego.

1933
The Mountain selected for the "Fourteenth Annual Exhibition of Painting and Sculpture," Los Angeles Museum.

June. First one-person exhibition at Stanley Rose Gallery on Vine Street in Hollywood.

September. One-person exhibition at the Assistance League.

December. Exhibits **Self Portrait** in the invitational, "Exhibition by Progressive Painters of Southern California," Fine Arts Gallery of San Diego.

Does easel paintings for the Federal Public Works Art Project (PWAP). Moves to Los Angeles where PWAP offices are located. Becomes involved in the formulation of Feitelson's theory of New Classicism (or Subjective Classicism), later known as Post-Surrealism.

1934
June. Exhibits first Post-Surrealist painting, **Persephone**, at the Fine Arts Gallery of San Diego in the "Eighth Annual Southern California Exhibition of Painting and Sculpture."
November. With Feitelson, participates in the first group showing of Post-Surrealist work at the Centaur Gallery in Hollywood.

Authors and publishes first theoretical manifesto entitled "New Classicism".

A loose association of artists who support this movement is formed which includes Lucien Labaudt and Knud Merrild. Grace Clements, Philip Guston, Reuben Kadish and others, exhibit in later shows.

1935
May. Exhibits **Double Portrait of the Artist in Time**, an important early work, in "Post-Surrealists and Other Moderns" at the Stanley Rose Gallery on Hollywood Boulevard. Although she had been painting only five years, it ranks as one of her outstanding achievements.

Participates in group exhibition of Post-Surrealists at the Hollywood Gallery of Modern Art on Hollywood Boulevard.

The Post-Surrealists mount a group exhibition at the San Francisco Museum of Art which travels to The Brooklyn Museum the following Spring, marking their first East Coast presentation.

1936
Because of East Coast exposure, Lundeberg, Feitelson and Merrild are invited to be part of "Fantastic Art, Dada, Surrealism" at the Museum of Modern Art, New York, in December. Is represented by Cosmicide, completed in 1935.

Completes two murals for the Los Angeles County Hall of Records for the California Works Progress Administration Federal Art Projects (WPA/FAP).

1937
Works as assistant on Feitelson's murals for Thomas A. Edison High School. Also makes four lithographs for the Project.

1938 -1942
Designs murals for the WPA/FAP including oil vignette on acoustic plaster and Petrachrome murals.

Murals still exist at Los Angeles Patriotic Hall, Venice High School Library, George Washington High School, Canoga Park High School, Fullerton Police Station and at Centinela Park.

1939
Executes the mural *History of Transportation* for the City of Inglewood, California.

1942
Exhibits in "Americans 1942 / 18 Artists from 9 States," The Museum of Modern Art, New York, with a group of Post-surrealist paintings.

Begins to paint "postcard" size paintings, among them the *Abandoned Easel* series, as a reaction to the scale and impersonality of work executed on mural projects. From this time on until 1958, continues to paint landscapes, interiors, and still-lifes which draw from memory, imagination, and observation, rather than from reality.

1949
Awarded first purchase prize for *The Clouds* in the "Ninth Invitational Purchase Prize Art Exhibition," sponsored by the Chaffey Community Art Association, California.

1950
Receives $1000 First Purchase Award for *Spring* in the "1950 Annual Exhibition / Artists of Los Angeles and Vicinity," Los Angeles County Museum.

Paints *A Quiet Place*, which presages later paintings such as *The Road* (1958), in which unmodulated geometric areas suggest three-dimensional space and perspective.

1950 -1958
Increasingly uses flat geometric areas and cast shadows to create spatial environment. Objects such as shells and fruits are depicted three-dimensionally.

1952
Exhibits *The Wind That Blew the Sky Away* in "The Pittsburgh International Exhibition of Contemporary Painting," Carnegie Institute, Pennsylvania.

1953
One-person retrospective at The Pasadena Art Institute, California.

1957
Awarded $400 prize for *Selma* in "1957 Annual Exhibition / Artists of Los Angeles and Vicinity," Los Angeles County Museum.

1958
Exhibits in joint retrospective with Feitelson at Scripps College, Claremont, California. Demarcates major turning points in their painting careers and reveals the distinct contrast between the two artists' work from 1933 to 1958.

1959
Begins series of paintings composed entirely of flat geometric areas, suggesting landscapes, interiors, and streets, as well as the effects of perspective, light, and shadow. Refers to three-dimensional reality, yet ambiguous.

1962
Participates in "Geometric Abstraction in America" at the Whitney Museum of American Art in New York, an important East Coast exhibition reaffirming her national recognition.

Paints the first work in her *Arches* series; introduces curved shapes.

Uses the white of primed canvas as form.

1963
Completes *Triptych*, one of her most important paintings of this period, noted by a shift in her palette from restrained tones to

stronger contrasts of color and value. Paints ribbons of color across entire width of three sections. Feitelson was encouraged to begin his Line paintings by her technical innovation of using masking tape to "draw" and paint lines.

1964
Continues work on the arch motif, exemplified by *Desert Light*. Uses black or white canvas to "frame" the view of abstract landscape as in *Desert View*.

Exhibits in "California Hard-Edge Painting" at the Pavilion Gallery, Balboa, California, marking the first official inclusion of her work in this movement.

1965
Switches to acrylics with *Planet #1* after solely using oils for thirty-five years.

Continues with her *Planet series*, returning to the Post-surrealist subject matter of planets and the cosmos, which fascinated her as a student.

Uses circle within black or colored square, which permits great variety of patterns suggesting, without modeling, a sphere in space.

1971
Retrospective exhibition of work from 1933 to 1971 at the La Jolla Museum of Contemporary Art, California. Described as "classicist" because of continual emphasis on aesthetic structure. Exhibition traces development from early works based on a Renaissance organizational plan, through Post-surrealist attitudes, to hard-edge forms.

1973 -1976
Works on second series of small pictures.

1974
Participates in "Nine Senior Southern California Painters," the opening exhibition of the Los Angeles Institute of Contemporary Art. This exhibition is mounted as a tribute to artists integral to the historical development of modernism in Southern California.

1978
Lorser Feitelson dies of heart failure.

1979
Concentrates on a series of land and seascapes, which are based on variations of one hue such as *Blue Calm*.

August. Returns to "interiors" and "painting-within-painting" themes with closely related grayed color, such as *Grey Interior I and II*.

Retrospective exhibition of work from 1933 to 1978 at the Los Angeles Municipal Art Gallery. Emphasizes Lundeberg's focus on the dimensions of space in early Post-Surrealist paintings as well as more abstract paintings of the sixties and seventies.

1980 -1981
Retrospective exhibition at San Francisco Museum of Modern Art, with Lorser Feitelson. The show travels to The Frederick S. Wight Art Gallery at UCLA in Los Angeles.

1981
Is honored with the Award for outstanding achievement in the visual arts by the College Arts Association and Women's Caucus for Art in San Francisco.

1982
The Graham Gallery in New York mounts exhibition surveying five decades of her work.

1983
The Palm Springs Desert Museum organizes "Helen Lundeberg Since 1970," a retrospective exhibition.

1987
Restoration of the Fullerton Police Station mural *History of Southern California*.

Tobey C. Moss Gallery produces documentary, "Helen Lundeberg - American Painter."

Receives the Vesta Award from the Woman's Building Art Center.

1988
The Los Angeles County Museum of Art hosts the exhibition "80th A Birthday Salute to Helen Lundeberg."

Receives the Palm Springs Desert Museum's Woman of the Year Award.

The mural *History of Transportation* raises preservation and conservation interest.

Retrospective exhibition at Mary Porter Sesnon Art Gallery in Santa Cruz.

1990

Receives an Honorary Doctorate Degree from the Otis-Parsons College of Art.

Receives a grant from the Richard A. Florsheim Art Fund for American Artists of Merit.

1993

Receives the Purchase Award from the American Academy of Arts and Letters.

1994

The Venice High School Library opens its doors to the public to view the mural, *History of California*.

1999

April 19, dies in Los Angeles.

Memorial exhibition at Tobey C. Moss Gallery.

May 23, a memorial is held at the Los Angeles County Museum of Art.

2000 - 2007

J. Paul Getty Grant Program "Preserve L.A." initiative awards the City of Inglewood a grant for the restoration and re-siting of *History of Transportation*. The mural is accepted into the California Register of Historical Resources.

The J. Paul Getty Grant Program, the California Heritage Fund Grant, the Park Bond 2000 Act and the Urban Recreational and Cultural Centers (URCC), combine funds to initiate restoration and relocation of the mural.

History of Transportation is removed for restoration and will be relocated to Grevillea Art Park in the City of Inglewood near City Hall. Rededication scheduled for Spring/Summer of 2007.

2004

"Helen Lundeberg and the Illusory Landscape" exhibition at Louis Stern Fine Arts

2007

"Infinite Distance - Architectural Compositions by Helen Lundeberg" exhibition at Louis Stern Fine Arts.

Initial information compiled from the 1980 exhibition catalogue,
Lorser Feitelson and Helen Lundeberg: A Retrospective Exhibition,
San Francisco Museum of Modern Art.

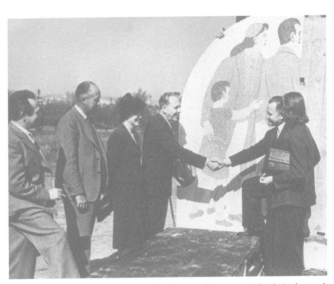

Dedication ceremony for *History of Transportation* in Inglewood, Helen Lundeberg far right, Lorser Feitelson far left.

SELECTED SOLO EXHIBITIONS

1933 Stanley Rose Gallery, Los Angeles, California.

Assistance League, Los Angeles, California.

1935 Stanley Rose Gallery, Los Angeles, California.

1949 **A Selected Group of Paintings by Lorser Feitelson and Helen Lundeberg,** The Art Center School Gallery, Los Angeles, California.

1952 Felix Landau Gallery, Los Angeles, California.

1953 The Pasadena Art Institute, Pasadena, California.

1958 Scripps College Art Galleries, Florence Rand Lang Art Building, Claremont, California. (with Lorser Feitelson)

1959 Paul Rivas Gallery, Los Angeles, California.

Santa Barbara Museum of Art, Santa Barbara, California.

1960 Paul Rivas Gallery, Los Angeles, California.

1961 Paul Rivas Gallery, Los Angeles, California.

1962 Ankrum Gallery, Los Angeles, California.

Paul Rivas Gallery, Los Angeles, California.

1963 Ankrum Gallery, Los Angeles, California.

Long Beach Museum of Art, Long Beach, California.

1964 Ankrum Gallery, Los Angeles, California.

1965 Occidental College, Los Angeles, California. (with George Baker)

1967 David Stuart Galleries, Los Angeles, California.

1970 David Stuart Galleries, Los Angeles, California.

1971 David Stuart Galleries, Los Angeles, California.

1971-72 **Helen Lundeberg / A Retrospective Exhibition,** La Jolla Museum of Contemporary Art, La Jolla, California. Catalogue published.

1972 **Lundeberg, Feitelson, First Showing: A Series of New Color Prints,** Los Angeles Art Association Galleries, Los Angeles, California.

1976 **Helen Lundeberg: Recent Small Paintings,** David Stuart Galleries, Los Angeles, California.

1977 David Stuart Galleries, Los Angeles, California.

1979 **Helen Lundeberg / A Retrospective Exhibition,** Los Angeles Municipal Art Gallery, Los Angeles, California. Catalogue published.

1980 **Helen Lundeberg: Selected Works,** The North Point Gallery, San Francisco, California.

1980-81 **Lorser Feitelson and Helen Lundeberg: A Retrospective Exhibition,** San Francisco Museum of Modern Art, San Francisco, California. Catalogue published. Also shown at The Frederick S. Wight Art Gallery, University of California, Los Angeles, California.

1981 **Helen Lundeberg: Paintings, Prints, Drawings,** Tobey C. Moss Gallery, Los Angeles, California.

1982 **Helen Lundeberg: Paintings through Five Decades,** Graham Gallery, New York, New York. Catalogue published.

Helen Lundeberg: Works on Paper, Tobey C. Moss Gallery, Los Angeles, California.

1983 **Helen Lundeberg Since 1970,** *Palm Springs Desert Museum, Palm Springs, California. Catalogue published.*

Helen Lundeberg: Paintings, *Tobey C. Moss Gallery, Los Angeles, California.*

University Art Museum, Santa Barbara, California.

1985 **Helen Lundeberg: Still Lifes,** *Tobey C. Moss Gallery, Los Angeles, California. Catalogue published.*

Helen Lundeberg: Recent Works, *Tobey C. Moss Gallery, Los Angeles, California. (with June Harwood)*

1987 **Helen Lundeberg: By Land and By Sea,** *Tobey C. Moss Gallery, Los Angeles, California.*

California Contemporary Artist: Helen Lundeberg, *Laguna Art Museum, Laguna Beach, California.*

1987-88 **Two Views: 1970-1987 / Helen Lundeberg & Martha Alf,** *Palos Verdes Art Center, Rancho Palos Verdes, California. Catalogue published.*

1988 **Helen Lundeberg: A Retrospective View,** *Mary Porter Sesnon Art Gallery, University of California, Santa Cruz, California. Catalogue published.*

1988-89 **80th A Birthday Salute to Helen Lundeberg,** *Los Angeles County Museum of Art, Los Angeles, California. Catalogue published.*

1989 **Helen Lundeberg: An American Visionary,** *Fresno Art Museum, Fresno, California.*

Helen Lundeberg: Paintings 1960 - 1963, *Tobey C. Moss Gallery, Los Angeles, California.*

1992 **Helen Lundeberg: The Sunset Years: 1980 - 1990,** *Tobey C. Moss Gallery, Los Angeles, California.*

1993 **Lundeberg & Feitelson: Together Again,** *Los Angeles Art Association, Los Angeles, California.*

1995 **Helen Lundeberg: Still Lifes and Interiors,** *Tobey C. Moss Gallery, Los Angeles, California.*

Helen Lundeberg: Then and Now, *Tobey C. Moss Gallery, Los Angeles, California.*

1997 **Helen Lundeberg: Still Life Through Five Decades,** *Tobey C. Moss Gallery, Los Angeles, California.*

1998 **Helen Lundeberg: Post-Surrealism to Hard Edge,** *Tobey C. Moss Gallery, Los Angeles, California.*

1999 **Helen Lundeberg: A Memorial Exhibition,** *Tobey C. Moss Gallery, Los Angeles, California.*

2001 **Helen Lundeberg: Inner Visions of Outer Space, Paintings, Drawings, Prints,** *Tobey C. Moss Gallery, Los Angeles, California.*

2004 **Helen Lundeberg and the Illusory Landscape: Five Decades of Painting,** *Louis Stern Fine Arts, West Hollywood, California. Catalogue Published.*

2006/07 **Fourteen Paintings by Helen Lundeberg,** *Residence of the French Consul, Los Angeles, California.*

2007 **Infinite Distance – Architectural Compositions by Helen Lundeberg,** *Louis Stern Fine Arts, West Hollywood, California. Catalogue Published.*

SELECTED GROUP EXHIBITIONS

1931 **Sixth Annual Exhibition of Southern California Art**, Fine Arts Gallery of San Diego, San Diego, California. Catalogue published.

1932 **Thirteenth Annual Painting and Sculpture Exhibition**, Los Angeles Museum, Los Angeles, California. Catalogue published.

1933 **Fourteenth Annual Exhibition of Painting and Sculpture**, Los Angeles Museum, Los Angeles, California. Catalogue published.

Progressive Painters of Southern California, California Palace of the Legion of Honor, San Francisco, California. Catalogue published.

Progressive Painters of Southern California, Fine Arts Gallery of San Diego, San Diego, California. Catalogue published.

1934 **Eighth Annual Southern California Exhibition of Painting and Sculpture**, Fine Arts Gallery of San Diego, San Diego, California. Catalogue published.

Paintings by California Modernists, Foundation of Western Art, Los Angeles, California.

Surrealism and Post-Surrealism (New Classicism), Centaur Gallery, Los Angeles, California.

1935 **Post Surrealist Exhibition**, San Francisco Museum of Art, San Francisco, California. Also shown at The Brooklyn Museum, Brooklyn, New York, 1936, under the title Postsurrealism.

Post-Surrealists and Other Moderns, Stanley Rose Gallery, Los Angeles, California.

Group exhibition, Hollywood Gallery of Modern Art, Los Angeles, California.

1936 **Fantastic Art, Dada, Surrealism**, The Museum of Modern Art, New York, New York. Catalogue published.

1938 **Postsurrealism**, Stendahl Galleries, Los Angeles, California.

1939 **Southern California Art Project**, Los Angeles Museum, Los Angeles, California. Catalogue published.

1942 **Americans 1942 / 18 Artists from 9 States**, The Museum of Modern Art, New York, New York. Catalogue published.

1944 **Fifth Annual Exhibition of Painting and Sculpture by Artists of Los Angeles and Vicinity**, Los Angeles County Museum, Los Angeles, California. Catalogue published.

Third Group Show, Los Angeles County Museum, Los Angeles, California. Catalogue published.

1945 **The First Biennial Exhibition of Drawings by American Artists**, Los Angeles County Museum, Los Angeles, California. Catalogue published.

1947 **Abstract and Surrealist American Art**, The Art Institute of Chicago, Chicago, Illinois. Catalogue published.

1949 **Ninth Invitational Purchase Prize Art Exhibition**, Chaffey Community Art Association, Ontario, California. Catalogue published.

1950 **1950 Annual Exhibition / Artists of Los Angeles and Vicinity**, Los Angeles County Museum, Los Angeles, California. Catalogue published.

1950 / Sixth Annual Exhibition by the Artists of Los Angeles and Vicinity, sponsored by Municipal Art Commission, Recreation and Park Commission and Council of the City of Los Angeles; shown at Greek Theatre, Los Angeles, California. Catalogue published.

University of Illinois Exhibition of Contemporary American Painting, College of Fine and Applied Arts, Urbana, Illinois. Catalogue published.

1951 **1951 Annual Exhibition / Contemporary Painting in the United States**, Los Angeles County Museum, Los Angeles, California. Catalogue published.

1951 / Seventh Annual Exhibition by the Artists of Los Angeles and Vicinity, sponsored by Municipal

Helen Lundeberg, circa 1937

Art Commission, Recreation and Park Commission and Council of the City of Los Angeles; shown at Greek Theatre, Los Angeles, California. Catalogue published.

University of Illinois Exhibition of Contemporary American Painting, College of Fine and Applied Arts, Urbana, Illinois. Catalogue published.

1952 **Pittsburgh International Exhibition of Contemporary Painting**, Carnegie Institute, Pittsburgh, Pennsylvania. Catalogue published.

University of Illinois Exhibition of Contemporary American Painting, College of Fine and Applied Arts, Urbana, Illinois. Catalogue published.

1953 **Fourteenth Artists West of the Mississippi**, Colorado Springs Fine Arts Center, Colorado Springs, Colorado. Catalogue published.

1953 Annual Exhibition / Artists of Los Angeles and Vicinity, Los Angeles County Museum, Los Angeles, California. Catalogue published.

Group exhibition, Pasadena Art Institute, Pasadena, California.

1954 **Functionists West**, Los Angeles Art Association Galleries, Los Angeles, California.

1955 **Contemporary American Painting and Sculpture**, College of Fine and Applied Arts, Urbana, Illinois. Catalogue published.

III Bienal de São Paulo, Museu de Arte Moderna de São Paulo, Brazil. Catalogue published. United States section organized by San Francisco Museum of Art: catalogue published under the title **Pacific Coast Art, United States' Representation at the IIIrd Biennial of São Paulo**. Also shown at Cincinnati Art Museum, Cincinnati, Ohio; Colorado Springs Fine Arts Center, Colorado Springs, Colorado; Walker Art Center, Minneapolis, Minnesota.

1956 **1956 Annual Exhibition / Artists of Los Angeles and Vicinity**, Los Angeles County Museum, California. Catalogue published.

62nd Annual for Western Artists, The Denver Art Museum, Denver, Colorado. Catalogue published.

1957 **Contemporary American Painting and Sculpture**, College of Fine and Applied Arts, Urbana, Illinois. Catalogue published.

1957 Annual Exhibition / Artists of Los Angeles and Vicinity, Los Angeles County Museum, Los Angeles, California. Catalogue published.

16th Artists West of the Mississippi, Colorado Springs Fine Arts Center, Colorado Springs, Colorado. Catalogue published.

1958 **Sixty-Eighth Annual Exhibition**, University of Nebraska Art Galleries, Lincoln, Nebraska. Catalogue published.

1959 **Contemporary American Painting and Sculpture, College of Fine and Applied Arts**, Urbana, Illinois. Catalogue published.

1960 **Fifty Paintings by Thirty-Seven Painters of the Los Angeles Area**, San Francisco Museum of Art, San Francisco, California. Catalogue published.

Painting From the Pacific: Japan, America, Australia, New Zealand, Auckland City Art Gallery, Auckland, New Zealand. Catalogue published.

1962 **The Artist's Environment: West Coast**, The Amon Carter Museum of Western Art, Fort Worth, Texas. Catalogue published. Organized by and shown at the UCLA Art Galleries, Los Angeles, California; also shown at Oakland Art Museum, Oakland, California.

Fifty California Artists, Whitney Museum of American Art, New York, New York. Catalogue published. Organized by San Francisco Museum of Art with the assistance of Los Angeles County Museum of Art. Also shown at Walker Art Center, Minneapolis, Minnesota; Albright-Knox Art Gallery, Buffalo, New York; and Des Moines Art Center, Des Moines, Iowa.

Geometric Abstraction in America, Whitney Museum of American Art, New York, New York. Catalogue published.

30 Friends, Los Angeles Art Association Galleries, Los Angeles, California.

1963 **Arts of Southern California - XIV: Early Moderns**, Long Beach Museum of Art, Long Beach, California. Catalogue published.

1964 **California Hard-Edge Painting**, Pavilion Gallery, Balboa, California. Catalogue published.

Of Time and The Image, Ankrum Gallery Artists, Phoenix Art Museum, Phoenix, Arizona. Catalogue published.

Early Moderns of Southern California, Long Beach Museum of Art, Long Beach, California.

1965 **1965 Annual Exhibition** / Contemporary American Painting, Whitney Museum of American Art, New York, New York. Catalogue published.

The San Francisco Collector, M. H. de Young Memorial Museum, San Francisco, California. Catalogue published.

Twelfth Exhibition of Contemporary American Painting and Sculpture, Krannert Art Museum, College of Fine and Applied Arts, University of Illinois, Urbana-Champaign, Illinois. Catalogue published.

1966 **Contemporary California Art from The Lytton Collection**, Lytton Center of The Visual Arts, Los Angeles, California. Catalogue published.

The Search / Ten Leading California Artsits in Pursuit of a Personal Vision, Lytton Center of The Visual Arts, Los Angeles, California. Catalogue published.

1967 **Artists' Artists**, Lytton Center of The Visual Arts, Los Angeles, California. Catalogue published.

1967 Annual Exhibition of Contemporary American Painting, Whitney Museum of American Art, New York, New York. Catalogue published.

Selected Artists - '67, Des Moines Art Center, Des Moines, Iowa. Catalogue published.

1968 **The California Landscape**, Lytton Center of The Visual Arts, Los Angeles, California. Catalogue published.

1968 Invitational, West Coast '68 Painters and Sculptors, E. B. Crocker Art Gallery, Sacramento, California. Catalogue published.

25 California Women of Art, Lytton Center of The Visual Arts, Los Angeles, California. Catalogue published.

Group exhibition, David Stuart Galleries, Los Angeles, California.

1969 **Color in Control**, Museum of Fine Arts, St. Petersburg, Florida. Catalogue published. Also shown at The Loch Haven Art Center, Orlando, Florida.

Group exhibition, David Stuart Galleries, Los Angeles, California (January).

Group exhibition, David Stuart Galleries, Los Angeles, California (July / August).

1970 **Group exhibition**, David Stuart Galleries, Los Angeles, California (July / August).

Group exhibition, David Stuart Galleries, Los Angeles California (November).

1974 **Nine Senior Southern California Painters**, Los Angeles Institute of Contemporary Art, Los Angeles, California. Catalogue published in Los Angeles Institute of Contemporary Art Journal, December 1974, pp. 45 - 53.

1976 **American Artists'76: A Celebration**, Marion Koogler McNay Art Institute, San Antonio, Texas. Catalogue published.

New Deal Art: California, de Saisset Museum, Santa Clara University, California. Catalogue published.

Painting and Sculpture in California: The Modern Era, San Francisco Museum of Modern Art, San Francisco, California. Catalogue published. Also shown at National Collection of Fine Arts, Smithsonian Institution, Washington, D.C.

1977 Still and Not So Still Lifes, Los Angeles Municipal Art Gallery, Los Angeles, California. Brochure published (biographical information only).

Surrealism and American Art: 1931-1947, Rutgers University Art Gallery, New Brunswick, New Jersey. Catalogue published.

Women in Surrealism, The Image and The Myth Gallery, Beverly Hills, Califronia.

Group exhibition, David Stuart Galleries, Los Angeles, California.

1979 The First Western States Biennial Exhibition, The Denver Art Museum, Denver, Colorado. Catalogue published. Also shown at National Collection of Fine Arts, Smithsonian Institution, Washington, D.C.; San Francisco Museum of Modern Art, San Francisco, California; and Seattle Art Museum, Seattle, Washington.

1981 Art from the Vice President's House, National Museum of American Art, Washington, D.C.

Los Angeles Prints, 1883-1980, Los Angeles County Museum of Art, Los Angeles, California. Catalogue published.

Painting and Sculpture in Los Angeles, 1900-1945, Los Angeles County Museum of Art, Los Angeles, California. Catalogue published.

Women of Art: Women's Caucus for Art Honors Exhibition, North Point Gallery, San Francisco, California. Catalogue published.

1982 The West As Art: Changing Perceptions of Western Art in California Collections, Palm Springs Desert Museum, Palm Springs, California. Catalogue published.

Drawings and Illustrations by Southern California Artists Before 1950, Laguna Beach Museum of Art, Laguna Beach, California. Catalogue published.

Realism and Realities, The Other Side of American Painting, 1940-1960, Rutgers University Art Gallery, New Brunswick, New Jersey. Catalogue published.

1983 Ceci n'est pas le surrealisme: California: Idioms of Surrealism, Fisher Gallery, University of Southern California, Los Angeles, California. Catalogue published.

American Prints & Drawings from the Federal Arts Project and Images of Work & Play: 1920s – 1950s, Tobey C. Moss Gallery, Los Angeles, California.

1984 Between the Olympics, Tobey C. Moss Gallery, Los Angeles, California.

1985 The Muse as Artist: Women in the Surrealist Movement, Jeffrey Hoffeld and Co. Gallery, New York, New York.

1986 California 1920-1945, Tobey C. Moss Gallery, Los Angeles, California.

Kindred Spirits, Los Angeles Municipal Art Gallery, Los Angeles, California.

Aspects of California Modernism 1920-1950, Federal Reserve System, Washington, D.C.

1986-1987 Elders of the Tribe, Bernice Steinbaum Gallery, New York, New York.

1987-1988 The Artists of California, Oakland Museum of Art, Oakland, California. Also shown at Crocker Art Museum, Sacramento, California; Laguna Art Museum, Laguna Beach, California.

The Artist's Mother: Portraits and Hommages. National Portrait Gallery, Washington, D.C.. Catalogue published. Also shown at the Heckscher Museum of Art, Huntington, New York.

1988-1989 **Women Artists of the New Deal Era: A Selection of Prints and Drawings**, National Museum of Women in the Arts, Washington, D.C.. Catalogue published.

1989 **Art in The Public Eye: Selected Developments**, Security Pacific Gallery, South Coast Metro Center, Costa Mesa, California. Catalogue published.

1990 **Functionists High**, The American Gallery, Los Angeles, California.

 Heroes, Heroines, Idols & Icons, Muckenthaler Cultural Center, Fullerton, California.

1990-1992 **Turning The Tide: Early Los Angeles Modernists 1920-1956**, Santa Barbara Museum of Art, Santa Barbara, California. Catalogue published. Also shown at Laguna Art Museum, Laguna Beach, California; Oakland Museum of Art, Oakland, California; Marion Koogler McNay Art Institute, San Antonio, Texas; Nora Eccles Harrison Museum of Art, Utah State University, Logan, Utah; Palm Springs Desert Museum, Palm Springs, California.

1991 **Greater Years, Greater Visions**, Irvine Fine Arts Center, Irvine, California.

1992 **Choice Encounters**, Long Beach Museum of Art, Long Beach, California.

1992-1993 **California Painting: The Essential Modernist Framework**, University Art Gallery, California State University, San Bernardino. Also shown at Fine Art Gallery, California State University, Redlands, California.

1993 **75 Years: 75 Works Collecting the Art of California**, Laguna Art Museum, Laguna Beach, California. Catalogue published.

1994 **Independent Visions: California Modernism 1940 - 1970**, Long Beach Museum of Art, Long Beach, California.

1994-1995 **A Generation of Mentors**, National Museum of Women in the Arts, Washington, D.C.. Catalogue published. Also shown at Fresno Metropolitan Museum, Fresno, California; Mount St. Mary's College, Los Angeles, California.

 Washington Print Club: 30th Anniversary Exhibition: Graphic Legacy, National Museum of Women in the Arts, Washington, D.C.. Catalogue published.

 Pacific Dreams: Currents of Surrealsim and Fanstasy in California Art, 1934-1957, UCLA/Hammer Museum of Art, Los Angeles, California. Catalogue published. Also shown at Oakland Museum of Art, Oakland, California; Nora Eccles Harrison Museum of Art, Utah State University, Logan, Utah.

1995-1996 **Independent Spirits: Women painters of the American West, 1890-1945**. Autry Museum of Western Heritage, Los Angeles, California. Catalogue published. Also shown at the Museum of Fine Arts, Santa Fe, New Mexico; Gilcrease Museum, Tulsa, Oklahoma; Museum of Art, Brigham Young University, Salt Lake City, Utah.

1996 **American Paintings in Southern California Collections: From Gilbert Stuart to Georgia O'Keefe**, Los Angeles County Museum of Art, Los Angeles, California. Catalogue published.

 California Focus, Long Beach Museum of Art, Long Beach, California.

 Grounded: Suburban Landscapes, Orange County Museum of Art, Newport Beach, California.

 Imaginary Realities: Surrealism Then and Now, Louis Stern Fine Arts, West Hollywood, California.

1997 **Sensuality in the Abstract**, Los Angeles Municipal Art Gallery, Los Angeles, California. Catalogue published.

 Made in California, City of Brea Gallery, City of Brea, California.

SELECTED PUBLIC AND CORPORATE COLLECTIONS

2000 **Made in California**, Los Angeles County Museum of Art, Los Angeles, California. Catalogue published.

Rooms with a View, Long Beach Museum of Art, Long Beach, California.

Pure de(Sign), Otis College of Art and Design - Ben Maltz Gallery, Los Angeles, California.

2002 **The Art of Giving: Recent Acquisitions of the Norton Simon Museum**, Norton Simon Museum, Pasadena, California. Brochure published.

2002-2003 **On Ramps / Post Surrealism: Genesis and Equilibrium / Pictures From the Cerebral World**, Pasadena Museum of California Art, Pasadena, California. Catalogue published. Also shown at Nora Eccles Harrison Museum of Art, Utah State University, Logan, Utah.

2003-04 **The Not So Still Life**, San Jose Museum of Art, San Jose, California. Catalogue published. Also shown at Pasadena Museum of California Art, Pasadena, California.

Into the Woods, Long Beach Museum of Art, Long Beach, California.

2004 **The LA That Influenced My Eye (curator Barry Berkus)**, Sullivan Goss, Santa Barbara, California.

2004/05 **The L.A. School of Painting**, Otis College of Art and Design - Ben Maltz Gallery, Los Angeles, California.

2005 **Surrealism USA**, National Academy Museum, New York, New York.

The First 80 Years, Gallery 825, Los Angeles, California.

2006 **Masters, Mentors, and Metamorphosis**, Fullerton College, Fullerton, California.

2007/08 **Birth of the Cool**, Orange County Museum of Art, Newport Beach, California.

Frederick R. Weisman Art Museum, Minneapolis, MN.

Fresno Art Museum, Fresno, CA.

Georgia Museum of Art, University of Georgia, Athens, GA.

Gibson, Dunn & Crutcher, Los Angeles, CA.

Honolulu Academy of Fine Arts, Honolulu, HI.

Joseph H. Hirshhorn Museum, Washington, D.C.

Laguna Art Museum, Laguna Beach, CA.

Long Beach Museum of Art, Long Beach, CA.

Los Angeles County Museum of Art, Los Angeles, CA.

Museum of Contemporary Art, San Diego, CA.

Museum of Fine Arts, Boston, MA.

National Museum of American Art, Smithsonian Institute, Washington, D.C.

Nora Eccles Harrison Museum of Art, Logan, UT.

Norton Museum of Art, West Palm Beach, FL.

Norton Simon Museum, Pasadena, CA.

Oakland Museum, Oakland, CA.

Orange County Museum of Art, Newport Beach, CA.

Palm Springs Desert Museum, Palm Springs, CA.

San Diego Museum of Art, San Diego, CA.

San Francisco Museum of Modern Art, San Francisco, CA.

Santa Barbara Museum of Art, Santa Barbara, CA.

San Jose Museum of Art, San Jose, CA.

Security Pacific Corporation, Los Angeles, CA.

Sheldon Memorial Art Museum, Lincoln, NE.

University of Arizona Museum of Art, Tucson, AZ.

University of New Mexico, Albuquerque, NM.

Washington University Gallery of Art, St. Louis, MO.

Whitney Museum of American Art, New York, NY.

Zimmerli Art Museum, Rutgers University, New Brunswick, NJ.

SELECTED BIBLIOGRAPHY

ON HELEN LUNDEBERG

Helen Lundeberg: American Painter. *Video, 56 minutes, Atmosphere Productions, 1987.*

Lundeberg, Helen. *Interview conducted by Betty Hoag, 17 March 1965. Archives of American Art, Smithsonian Institution, Washington, D.C. (with Lorser Feitelson), reel 3419.*

_____. *Interview conducted by Jan Butterfield, 29 August 1980. Archives of American Art, Smithsonian Institution. Washington, D.C., reel 3198.*

_____. **Helen Lundeberg.** *Oral History Program, University of California, Los Angeles (1982), interviewed by Fidel Danieli.*

New Deal Art: California. *Video interview conducted by Lydia Modi Vitale and Steven Gelber, 14 March 1975. de Saisset Museum, Santa Clara University, California. (with Lorser Feitelson).*

Olson, Joan Peterson. *"A Critical Analysis of Space in the Painting of Helen Lundeberg." Thesis, California State University, Long Beach, 1988.*

GENERAL REFERENCES

Baur, John I. H. **Revolution and Tradition in Modern American Art.** *Cambridge: Harvard University Press, 1951, p.106.*

Catalogue of the Permanent Collection of Painting and Sculpture. *San Francisco: San Francisco Museum of Art, 1970, pp.102-103.*

Cummings, Paul. **Dictionary of Contemporary American Artists.** *New York: St. Martin's Press, 1977, p. 321.*

Heller, Nancy G. **Women Artists: An Illustrated History.** *New York: Abbeville Press, 1987, pp. 159-160.*

Hopkins, Henry. **50 West Coast Artists: A Critical Selection of Painters and Sculptors Working in California with Portraits by Mimi Jacobs.** *San Francisco: Chronicle Books, 1981, pp. 108-109.*

_____. **California Painters: New Work.** *San Francisco: Chronicle Books, 1989, pp.94-96.*

Jean, Marcel. **The History of Surrealist Painting.** *New York: Grove Press, 1960, p. 273.*

Kahan, Mitchell Douglas. *"Subjective Currents in American Painting of the 1930s." Ph.D. dissertation, City University of New York, 1983.*

Karlstrom, Paul, J. (ed.) **On the Edge of America: California Modernist Art, 1900-1950.** *Berkeley: University of California, 1996, pp. 174-176, 183-191.*

Marrow, Marva. **Inside the L. A. Artist.** *Salt Lake City: Peregrine Smith Books, 1988, p. 65.*

Monro, Isabel Stevenson and Kate M. Monro. **Index to Reproductions of American Paintings.** *New York: H. W. Wilson, 1948, p. 398.*

_____. **Index to Reproductions of American Paintings. First Supplement.** *New York: H. W. Wilson, 1964, p. 267.*

Moore, Sylvia. **Yesterday and Tomorrow: California Women Artists.** *New York: Midmarch Arts Press, 1989.*

Moure, Nancy Dustin Wall. **Dictionary of Art and Artists in Southern California Before 1930.** *Los Angeles: Dustin Publications, 1975, p. 155.*

_____. **and Phyllis Moure. Artists' Clubs and Exhibitions in Los Angeles Before 1930.** *Los Angeles: Dustin Publications, 1975.*

Munro, Eleanor. **Originals: American Women Artists.** *New York: Simon & Schuster, 1979, pp. 25, 170-177, 494-495n.*

Plagens, Peter. **Sunshine Muse: Contemporary Art on the West Coast.** *New York: Praeger, 1974, pp. 18-19, 117.*

Pousette-Dart, Nathaniel. (ed.) **American Painting Today.** *New York: Hastings House, 1956, p. 55.*

Rickey, George. **Constructivism: Origins and Evolution.** *New York: George Braziller, 1967, pp. 132-133.*

Rubinstein, Charlotte S. **American Women Artists: From the Early Indian Times to the Present.** *Boston: G.K. Hall, New York: Avon Books, 1982, pp. 252-254, 336.*

Smith, Lyn Wall, and Nancy Dustin Wall Moure. **Index to Reproductions of American Paintings.** *Metuchen, N. J.: Scarecrow Press, 1977, p. 379.*

Trenton, Patricia. (ed.) **Independent Spirits: Women Painters of the American West, 1890-1945.** *Berkley: University of California Press, 1995, pp. 74, 80, 92, 93, 96, 98, 102.*

ARTICLES AND REVIEWS
R: review

1933 Millier, Arthur. *"Something for All Tastes on Week's Art Bill of Fare." Los Angeles Times, 10 September 1933, Il, p. 4. R.*

1934 Millier, Arthur. *"Surrealists Take Time by Forelock and Stage Exhibit." Los Angeles Times, 25 November 1934, Il. p. 6. R.*

1935 *"Paint, Theory, Prints Liven This Week's Art Exhibitions." Los Angeles Times, 29 September 1935, Il, p.7. R.*

1936 Clements, Grace. *"New Content – New Form." Art Front, March 1936.*

Jewell, Edward Alden. *"Brisk Pace in Museums." The New York Times, 17 May 1936, p.10. R.*

Mac-Gurrin, Buckley. *"Home-made Art Movement Performs as Scheduled." Rob Wagner's Script (Los Angeles), 25 July 1936, p. 16.*

"Postsurrealism, the Supermodern." The Literary Digest, 11 July 1936, p. 23. R.

1939 "Hitting High Spots of Midseason Art Show." Los Angeles Times, 12 March 1939, III, p. 8. R.

1940 "First Section of World's Longest Petrachrome Mural Installed in Park." Los Angeles Times, 6 November 1940, p. 16.

1941 "Fullerton City Hall." Architect and Engineer, December 1941, pp. 24-25.

1943 Millier, Arthur. "W. P. A. Art Project's Last Works Adorn Patriotic Hall." Los Angeles Times, 10 January 1943, III, p. 5.

M[illier], A[rthur]. "Mysticism and Allegory Mark Associations Show." Los Angeles Times, 31 January 1943, III, p. 5. R.

1944 "Los Angeles Museum's 3rd Group Show." Arts and Architecture, October 1944, pp. 19, 22.

Macdonald-Wright, S. "Art." Rob Wagner's Script (Los Angeles), 21 October 1944, p. 30.

1945 Dickey, Dan. "The Visual Arts." San Diego Daily Journal, 11 January 1945, pp. 18-19. R.

M[illier], A[rthur]. "Woman Has Edge in Show of Drawings." Los Angeles Times, 7 Janury 1945, III, p. 4. R.

1948 Millier, Arthur. "Imaginative, Fantastic in Art Shown." Los Angeles Times, 4 January 1948, III, p.4. R.

_____. "Youth Keys Southland's Art Display." Los Angeles Times, 23 May 1948, III, p. 6. R.

1949 "Dual Show seen in Works at Art Center Galleries." Los Angeles Daily News, 16 July 1949, p. 21. R.

Frankenstein, Alfred. "Around the Local Galleries." San Francisco Chronicle, 10 April 1949, pp. 19-20. R.

Millier, Arthur. "Exhibit is Contrast of Vigor and Delicacy." Los Angeles Times, 17 July 1949, IV, p. 6. R.

1950 "$1000 Purchase Prize Winner in L.A. County Museum's Annual Art Exhibition." Los Angeles Times, 2 July 1950, p. 31.

Millier, Arthur. "Los Angeles Local Embraces a State-Size Area." Art Digest, 1 July 1950, p. 14. R.

Millier, Arthur. "Park Show worthy of Local Pride." Los Angeles Times, 2 July 1950, pp. 1, 7. R.

Ross, Kenneth. "Artists of Los Angeles Area Open 1950 Annual Exhibition at County Museum." Los Angeles Daily News, 1 July 1950, p. 31. R.

1951 Biggs, Gloria. "Uncompromising Devotion to Fine Arts Clears Path for California Woman." Christian Science Monitor, 16 May 1951, p. 6P.

"City Hall Gallery Exhibits Paintings." Los Angeles Times, 23 November 1951, II, p. 18. R.

Langsner, Jules. "Art News from Los Angeles." Art News, December 1951, p. 63. R.

1952 Langsner, Jules. "Art News from Los Angeles." Art News, March 1952, p. 53. R.

_____. "Art News from Los Angeles." Art News, November 1952, p. 50. R.

1953 Langsner, Jules. "Art News from Los Angeles." Art News, December 1953, pp. 50, 65. R.

Lee, Jennifer. "Art and Artists." Pasadena Star-News, 29 November 1953, p. 14. R.

Millier, Arhur. "Lundeberg Hailed for Nostalgia." Los Angeles Times, 29 November 1953, IV, p. 7. R.

Wight, Frederick S. "Los Angeles." Art Digest, 1 December 1953, p. 18. R.

1955 Macdonald-Wright, S. "Art News form Los Angeles." Art News, October 1955, p. 59. Reprinted in Los Angeles Institute of Contemporary Art Journal, April-May 1975, pp. 44-45.

1958 Langsner, Jules. "This Summer in Los Angeles." Art News, Summer 1958, p. 58. R.

Millier, Arthur. "Feitelson's Show Works." Los Angeles Times, 30 March 1958, V, p. 7. R.

1959 Langsner, Jules. "Art News from Los Angeles." Art News, Summer 1959, p. 60. R.

Millier, Arthur. "11 Leading Southland Oil Painters." Los Angeles Times, Home Magazine, 22 February 1959, pp. 13, 15-16.

Seldis, Henry J. "In the Galleries." Los Angeles Times, 11 October 1959, V, p. 6. R.

1960 Frankenstein, Alfred. "An Extraordinary Show of Art from the Southland." San Francisco Chronicle, 28 August 1960, p. 27. R.

Langsner, Jules. "Art News from Los Angeles." Art News, December 1960, pp. 46, 50. R.

Seldis, Henry J. "In the Galleries." Los Angeles Times, Calendar, 9 October 1960, p. 18. R.

Weller, Allen S. "The New Romanticism." Art in America, 48:4 (1960), pp. 42, 44.

1961 Seldis, Henry J. "In the Galleries." Los Angeles Times, 9 June 1961. R.

1962 Canaday, John. "Visitors from the West." The New York Times, 28 October 1962. R.

Langsner, Jules. "Art News from Los Angeles." Art News, February 1962, p. 48. R.

McClellan, Doug. "Helen Lundeberg, Paul Rivas." Artforum, September 1962, p. 16. R.

Perkins, Constance. "30 Friends, Los Angeles Art Association." Artforum, 1:7 December 1962, pp. 18-19. R.

Tillim, Sidney. "Month in Review." Arts, December 1962, pp. 39, 41. R.

Wight, Frederick S. "Three Los Angeles Artists." Art in America, 50:1 (1962), pp. 89-90.

1963 Desenberg, Irma E. "Helen Lundeberg, Long Beach Art Museum." Artforum, July 1963, pp. 46-47. R.

Frankenstein, Alfred. "Big Group Shows Emphasize the Experienced." San Francisco Chronicle, This World, 24 March 1963, pp. 23-24. R.

1964 Coplans, John. "Circle of Styles on the West Coast." Art in America, June 1964, p. 33.

_____. "Formal Art." Artforum, Summer 1964, pp. 42, 45.

Ewalt, Mary. "Early Modern Paintings by California Artists, Long Beach Museum of Art." Artforum, February 1964, p. 12. R.

Howell, Betje. "Helen Lundeberg, Ankrum Gallery." Artforum, December 1964, pp. 18, 44. R.

Millier, Arthur. "An 'Inside' Artist Moves 'Outside.'" Los Angeles Times, 25 October 1964. R.

Perkins, Constance. "An Active Center of Hard Edge Art." Los Angeles Times, 13 March 1964, IV, p. 4. R.

Seldis, Henry J. "Nostalgia Haunts Recent Lundeberg Canvases." Los Angeles Times, 19 October 1964, V, p. 14. R.

von Breton, Harriet. "Phoenix." Artforum, September 1964, pp. 48-49.

1965 Siple, Molly. "Helen Lundeberg, George Baker, Occidental College." Artforum, May 1965, p. 14. R.

Wurdemann, Helen. "A Stroll on La Cienega." Art in America, October–November 1965, p. 115. R.

1966 Kurzen, Estelle. "Los Angeles." Artforum, December 1966, pp. 60-61. R.

Sedis, Henry J. "Locals Get Chance in Lytton Exhibit." Los Angeles Times, 4 July 1966, V, p. 13. R.

Wilson, William. "Didactic Exhibit at Lytton Gallery." Los Angeles Times, 21 October 1966, p. 10. R.

1967 "Art News: Angelenos on 'Select' List." Los Angeles Times, *Calendar, 24 December 1967, p. 31.*

1968 Seldis, Henry J. "Landscapes at Lytton Center." Los Angeles Times, *5 August 1968, IV, p. 6. R.*

Wilson, William. "Women' Exhibition Nicely Balances Art, Femininity." Los Angeles Times, *18 March 1968, IV, p. 14. R.*

1970 Seldis, Henry J. "Art Walk." Los Angeles Times, *6 March 1970, IV, p. 8. R.*

Young, Joseph E. "Los Angeles." Art International, *Summer 1970, p. 111. R.*

1971 Seldis, Henry J. "Art Walk." Los Angeles Times, *5 March 1971, IV, p. 8. R.*

Young, Joseph E. "Helen Lundeberg: An American Independent." Art International, *September 1971, pp. 46-53, 72.*

1972 Hagberg, Marilyn. "Poetic Mysteries." Artweek, *8 January 1972, p. 1. R.*

Seldis, Henry J. "Los Angeles." Art International, *Summer 1972, pp. 113-144. R.*

_____. "A Poetess Among Painters." Los Angeles Times, *10 January 1972, IV, p. 4. R.*

Wilson, William. "A New Life for Art of the New Deal." Los Angeles Times, *4 May 1972, IV, pp. 3, 15.*

_____. "Saving the W.P.A. Murals." Los Angeles Times, *21 August 1972, IV, p. 3.*

1973 Plagens, Peter. "Before What Flowering? Thoughts on West Coast Art." Artforum, *September 1973, pp. 36-37.*

1974 Danieli, Fidel. "Nine Senior Southern California Painters." Los Angeles Institute of Contemporary Art Journal, *October 1974 pp. 32-34.*

Lundeberg, Helen. "Statement." Sourcebook, *November – December 1974.*

Seldis, Henry J. "The Pioneer Modernists: A Sure Cure for Amnesia." Los Angeles Times, *Calendar, 8 December 1974, p. 102. R.*

Wortz, Melinda. "Nine Senior Los Angeles Artists." Artweek, *14 December 1974, pp. 1, 16, R.*

1975 Danieli, Fidel. "Peter Krasnow: Pioneer Los Angeles Modernist." Artweek, *22 March 1975, p. 5.*

1976 Frankenstein, Alfred. "A Confrontation with the Modern Era." San Francisco Chronicle, *World, 12 September 1976, pp. 33-34. R.*

Seldis, Henry J. "Way Out West: Landscape to Urbanity." Los Angeles Times, *Calendar, 12 September 1976. R.*

1977 Albright, Thomas. "California Art Since the Modern Dawn." Art News, *January 1977, p. 70. R.*

"Art Walk." Los Angeles Times, *14 January 1977, IV, p. 10. R.*

Kramer, Hilton. "A Survey of California Art." The New York Times, *19 June 1977, p. 27. R.*

Seldis, Henry J. "Still Lifes" Los Angeles Times, *22 May 1977, p. 82. R.*

St. John, Terry. "Two Pioneering Southern California Modernists." ART (Publication of the Art Guild of the Oakland Museum Association), *May - June 1977.*

Zimmerer, Kathy. "Women in Surrealism." Artweek, *26 March 1977. R.*

1979 Howell, Betje. "First L.A. Exhibit for Helen Lundeberg." Evening Outlook, *27 January 1979. R.*

Hugo, Joan. "Determination of Vision." Artweek, *3 February 1979, pp. 1, 20. R.*

Moran, Diane. "Helen Lundeberg: The Sixties and Seventies." Art International, *May 1979, pp. 35-43 and cover.*

Perlmutter, J. "The First Western States Biennial Exhibition." Art Voices; South, *September-October 1979, pp. 25-26. R.*

Wilson, William. "Lundeberg: Painting the Problems." Los Angeles Times, *Calendar, 21 January 1979. R.*

1980 Albright, Thomas. "Hard Adge Modernists From Southern California." Review, *12 October 1980. pp. 14-15.*

Dunham, Judith L. "Lorser Feitelson and Helen Lundeberg: Collaborative Lives, Individual Achievements." Artweek, *1 November 1980, p. 1. R.*

1981 "Artitst Honored" Sterling Journal - Advocate, *1 April 1981.*

Ianco-Starrels, Josine. "Pioneer Couple Share Billing." Los Angeles Times, *Calendar, 15 March 1981. R.*

Wilson, William. "Sensitive Palettes of Feitelson - Lundeberg." Los Angeles Times, *Calendar, 5 April 1981, pp. 1, 92.*

1982 "Galleries", Los Angeles Times, *14 May 1982, VI. R.*

Hopkins, Henry. "Is the Mainstream Flowing West?" ArtNews, *January 1982, pp. 73-79. (Excerpt from Hopkins, Henry. 50 West Coast Artists: A Critical Selection of Painters and Sculptors Working in California with Portraits by Mimi Jacobs. San Francisco: Chronicle Books, 1981.)*

Moran, Diane Degasis. "Post-Surrealism: The Art of Lorser F Feitelson and Helen Lundeberg." Arts Magazine, *December 1982, pp. 124-128.*

1983 Carlson, Prudence. "Deep Space." Art in America, *February 1983, pp. 104-107.*

Fort, Ilene Susan. "Helen Lundeberg." Arts Magazine, *January 1983, pp. 34-35. R.*

Muchnic, Suzanne. "Succeeding in Infinite Space." Los Angeles Times, *Calendar, 22 May 1983, p. 90.*

1984 Hammond, Pamela. "A Tiny Gallery's Olympian Show." Los Angeles Reader, *27 July 1984, p. 6. R.*

Nelson, Sandy. "Celebrating Los Angeles Art – 1984." Images and Issues, *July-August 1984, pp. 30-35.*

Wilson, R. L. "California Surrealism." Artweek, *17 March 1984, p. 4. R.*

1985 Bulmer, Marge. "Quiet and Timeless Moments." Artweek, *30 November 1985, p. 3. R.*

Chadwick, Whitney. "The Muse as Artist: Women in the Surrealist Movement." Art in America, *July 1985, pp. 120-129. R.*

Muchnic, Suzanne. "Wilshire Center." Los Angeles Times, *Calendar, 19 April 1985, VI, p. 5. R.*

Muchnic, Suzanne. "Art Conferees Get the Big Picture." Los Angeles Times, *Calendar, 16 February 1985.*

Welchman, John. "California Had its Own Avant-Garde." Artnews, *May 1985, pp. 105-106.*

1986 Ballatore, Sandy. "Helen Lundeberg: Spaces in the Mind." Visions: The Los Angeles Art Quaterly, *no.1, 1986, pp. 21-23.*

Kane, John. "City to restore Mural." Fullerton News Tribune, *18 December 1986, pp. 1-2.*

LaPalma, Marina. "A Conjunction of Affinities." Artweek, *17 May 1986. R.*

Muchnic, Suzanne. "Exploring Emotional Connections in 'Kindred Spirits'." Los Angeles Times, *Calendar, 5 May 1986.*

Schipper, Merle. "Helen Lundeberg." Artnews, *March 1986, p. 121. R.*

1987 Brown, Betty Ann. "Seeking Utopias of the Mind." Artweek, *31 October 1987, p. 1. R.*

Dubin, Zan. "Woman's Building Awards: Picture for Women Artists Brighter." Los Angeles Times, *16 October 1987, VI, p. 22.*

Curtis, Cathy. "Wilshire Center." Los Angeles Times, *Calendar, 2 October 1987, p. 20. R.*

Goldman, Leah. "Ambiguities of Space." Artweek, *18 April 1987. R.*

Manteneri, Joe. "Old City Mural to be Restored." Fullerton News Tribune, *12 February 1987.*

Maxfield, David M. "Myth and Might of Southern California's Visual Arts." Antiques West Newspaper, January 1987, pp. 11, 15.

Vanderknyff, Rick. "'Rediscovered' Mural Grabs the Spotlight." Los Angeles Times, Calendar, 10 July 1987.

Vanderknyff, Rick. "A Benefit to Restore Artwork." Los Angeles Times, Calendar, 16 September 1987, p. 3.

1988 Donahue, Marlena. "Celebrating the Independent Lundeberg." Los Angeles Times, Calendar, 3 November 1988. R.

Dubin, Zan. "A Tribute to 'One of Our Own People.'" Los Angeles Times, Calendar, 23 October 1988, p. 9. R.

Rotella, Sebastian. "Inglewood OKs $10,000 to Help Restore Mural." Los Angeles Times, Metro, 6 October 1988.

1989 Margolis, Judith. "Evolution of an Explorer." Artweek, 7 January 1989, pp. 4-5. R.

Wilson, William. "The Blossoming of L.A. Artists in 88." Los Angeles Times, Calendar, 1 January 1989, p. 72.

1990 McQueeney, Tom. "Obscured Mural Will Become Art Again Through Restoration Project." Los Angeles Times, Metro (Orange County Ed.), 21 January 1990, p. 5.

Wilson, William. "Originality Rolls in on a Timeless Tide." Los Angeles Times, Calendar, 1 August 1990, F, p. 1. R.

1991 Baker, Kenneth A. "California Abstractionists of the 1940's and 1950's." Architectural Digest, May 1991, pp. 66, 70, 74, 76.

Curtis, Cathy. "Secret of Irvine Center Exhibit is that the Works are Ageless." Los Angeles Times, Calendar (Orange County Ed.), 19 August 1991, p. 3. R.

Curtis, Cathy. "Fullerton to Restore '42 Lundeberg Mural." Los Angeles Times, Calendar (Orange County Ed.), 19 September 1991, p. 2.

Ehrlich, Susan. "Helen Lundeberg: Between Reality and Dream." Artspace 15, January-February 1991, pp. 35-39.

1992 Colker, David. "Sunset as a Quality of Light, Not Life." Los Angeles Times, Calendar, 5 April 1992, p. 86. R.

Dubin, Zan. "Drawn by Art of Surreal." Los Angeles Times, Calendar (Orange County Ed.), 30 July 1992, p. 2.

Kim, Rose. "TLC Is Conserving WPA Mural." Los Angeles Times, Metro (Orange County Ed.), 9 February 1992, p. 1.

Nieto, Margarita. "Helen Lundeberg." ArtScene, May 1992, p.18.

1994 Pleasure, Thomas. "Venice: Uncovering a Hidden Treasure." Los Angeles Times, Westside, 24 July 1994, p. 8.

"The WPA Projects: Public Art Throughout the San Fernando Valley." Los Angeles Times, Metro, 13 November 1994, p.2.

1995 Ehrlich, Susan. "Pacific Dreams: Currents of Surrealism & Fantasy." American Art Review, August-September 1995, pp. 130-135, 159. R.

Kandel, Susan. "'Mentors' Champions 12 Local Women in Art." Los Angeles Times, Calendar, 23 Febrary 1995, p. 1. R.

Knight, Christopher. "'California' Dreamin': Hammer Museum Exhibition Uncovers a Quirky Wave of Surrealism." Los Angeles Times, Calendar, 13 July 1995, p. 1. R.

Wilson, William. "Helen Lundeberg's Quest for Purity, Reality, Illusion." Los Angeles Times, Calendar, 25 September 1995, p. 9. R.

1996 Curtis, Cathy. "Shaky Outing for OCMA's 'Other' Venues." Los Angeles Times, Calendar (Orange County Ed.), 19 January 1996, p. 2. R.

Duncan, Michael. "West Coast Surreal." Art in America, January 1996, pp. 38-41, 43, 45. R.

Duncan, Michael. "What's Wrong With This Picture?" L.A. Weekly, 20 – 26 December 1996, pp. 62-63.

Grad, Shelby. "Cities Face the WPA Question: Such a Deal or No Big Deal?" Los Angeles Times, Metro, 24 January 1996, p. 3.

"Inglewood Weighs Restoration of Depression-Era Mural." Los Angeles Times, Metro, 17 May 1996, p. 5.

Knight, Christopher. "A New Exhibition Canvases a Variety of Private Owned Works that Aren't Often Publicly Accessible." Los Angeles Times, Calendar, 31 March 1996, p. 60. R.

Muchnic, Suzanne. "Finally Giving California a Fair Shake." Los Angeles Times, Calendar, 8 December 1996, p. 55. R.

Wilson, William. "'Focus' Surveys California's Art Landscape." Los Angeles Times, Calendar, 16 August 1996, p. 31. R.

Wilson, William. "Mixed Bag is Brought into Focus." Los Angeles Times, Calendar (Orange County Ed.), 20 September 1996, p. 28. R.

1997 Colpitt, Frances. "Looking West." Art Journal, Winter 1997, pp. 88-90. (Book Review).

Cutajar, Mario. "Helen Lundeberg." ArtScene, October 1997.

Finch, Christopher. "Hard-Edge Painting." Architectural Digest, April 1997, pp. 190-193, 222-223.

Pagel, David. "Art Review." Los Angeles Times, Calendar, 10 October 1997, p. 28. R.

Tapley, George. "Helen Lundeberg." Artweek, December 1997.

Wilson, William. "'Sensuality' invites Tickle of Tactility." Los Angeles Times, Calendar, 26 March 1997, p. 10. R.

1998 Heimann, Jim. "Inglewood's Overlooked WPA Jewel." Los Angeles Times Magazine, 11 January 1998, p. 6.

Rogers, Terrence. "City of Vapor: Capturing the Transitory Reality of Los Angeles." American Artist, July 1998, pp. 28-36, 72-73.

1999 Haithman, Diane. "Helen Lundeberg; Artist, Pioneer of the New Classicism Movement." Los Angeles Times, 21 April 1999, A, p. 23.

Karlstrom, Paul, J. "West Coast." Archives of American Art Journal, 1999, vol. 39, pp. 54-57.

2000 Fahlman, Betsy. "Independent Spirits: Women Painters of the American West, 1890-1945." Woman's Art Journal, Spring / Summer 2002, pp. 46-48. R.

2001 Ollman, Leah. "Art Reviews." Los Angeles Times, Calendar, 19 October 2001, p. 24. R.

2002 Chang, Richard. "In a Golden State: Visual Art a New Museum in Pasadena is Home for More than California Works." The Orange County Register, 23 June 2002. R.

DiMichele, David. "'On-Ramps' at the Pasadena Museum of California Art." Artweek, September 2002, pp. 18-19. R.

Harvey, Doug. "Merging Artists." LA Weekly, 2 August 2002. R.

Knight, Christopher. "Ambitious Goals, Modest Results for Museum of California Art." Los Angeles Times, Calendar, 1 June 2002, p. 1. R.

2003 "Committee Saves Piece of Southern California Histroy." Inglewood News, 18 December 2003, pp. 1, 3.

2004 Muchnic, Suzanne. "Art: TLC for a Mural." Los Angeles Times, Calendar, 11 January 2004, pp. E1, E52.

Pagel, David. "Around the Galleries." Los Angeles Times, Calendar, 4 June 2004, p. E16. R.

2005 Sullivan, Missy. "Hidden Treasures of American Painting." Forbes Collector, March 2005, pp. 1-2.

Duncan, Michael. "Landscape Seen and Thought." Art in America, April 2005, pp. 138-141. R.

2007 Boone, Lisa. "A Fine Time for Art." Los Angeles Times, Home. 18 January 2007, p. F5.

"Los Angeles Art Show Brings to Light Art Throughout the Centuries in S. M.." The Argonaut, 25 January 2007.

144

Essay by Marie Chambers

Photography by Ed Glendinning

Cover: ARCANUM # 6, 1970
acrylic on canvas, 60 x 60 inches
152.4 x 152.4 centimeters

Design: Lilla Hangay, Santa Ana, California
Production: C&C Offset Printing, Portland, Oregon
Typeface: Corisande
Printed on Japanese matte art
Edition of 7,000

Published by Louis Stern Fine Arts and
the Feitelson Arts Foundation.

ISBN 978-0-9749421-6-2

Library of Congress Control Number 2007922800

Printed in China